M000294332

GHOSTS OF
SANTA BARBARA
AND THE OJAI VALLEY

Oct. 20, 2018

GHOSTS OF
SANTA BARBARA
AND THE OJAI VALLEY

To: James,
I hope you enjoy the
Stories — Best regards,
Evie Ybarra

EVIE YBARRA

Haunted America

Published by Haunted America
A Division of the History Press
Charleston, SC
www.historypress.net

Copyright © 2017 by Evie Ybarra
All rights reserved

Front cover: photographed by Robert G Jr.
Back cover: photographed by Robert G Jr.; *top inset*: Ojai Valley Museum; *bottom inset*:
Jeremy Leija.

First published 2017

Manufactured in the United States

ISBN 9781625859495

Library of Congress Control Number: 2017940934

Notice: The information in this book is true and complete to the best of our knowledge. It is
offered without guarantee on the part of the author or The History Press. The author and
The History Press disclaim all liability in connection with the use of this book.

All rights reserved. No part of this book may be reproduced or transmitted in any form
whatsoever without prior written permission from the publisher except in the case of brief
quotations embodied in critical articles and reviews.

To Robert, whom I have known since I was seventeen, thank you for your unwavering support and encouragement.
For my four beautiful grandchildren, Michael, Christopher, Conner and Claire, I hope you enjoy history and stories as much as I have. To all of my former students whose lives touched mine and who taught me the importance of sharing stories, myths and legends.

CONTENTS

Acknowledgements

Thank you to all of those who have supported this project. Robert G. Jr., your photography skills are quite excellent and artistic, and your time was precious. Yet, you shared that in order to complete this book.

T Christian Gapen and Southland Publishing, your outstanding photographs of Santa Cruz Island make the experience come to life for those who have not had the privilege of visiting any of the Channel Islands. Jeremy Leija and his original artwork add an extra dimension to the unknown and to the Ghostly Lady.

Colleen Cason and the *Ventura County Star* for sharing "The Silent Witness" series written by Colleen.

Thank you to the *Sacramento Bee* and Marc Breton for his articles about the East Area Rapist. To all those who shared their stories and experiences, thank you.

The Ojai Valley Museum has been so gracious in sharing information and photographs, and it is greatly appreciated.

Thank you to Katherine Stewart, author of *The Good News Club*, for sharing her two articles from *Santa Barbara* magazine, "Almost Famous" and "Into the Light," because a book about Santa Barbara would not have been complete without a glance into the lives of Edie Sedgwick and Martha Graham. There are numerous others included in the book, such as Barnaby and Mary Conrad, Countess Ritter and Fanny Stevenson, the widow of Robert Louis Stevenson. To those of you who consented to be interviewed, it is greatly appreciated. Thank you. The communities of Santa Barbara

and Montecito were extremely helpful and your stories are important for the historical record. Thanks also to Hattie Beresford, renowned historian, and to Francesca C. Hunter for sharing their stories.

The San Ysidro Ranch was so gracious. Without their assistance, the book would not have been complete. Last, but not least, I am immensely grateful to Laurie Krill of The History Press for her constant encouragement and assistance in completing this project and to Rick Delaney for his dedication and thoroughness.

INTRODUCTION

Ghosts are real. Shadow people are real. This book affirms these beliefs because it validates the sightings and the stories people have shared over the years. If you have never seen a ghost or apparition or noticed dark shadows moving about in your home or elsewhere, this book will inform you about these unknown entities through stories others have shared. Manifestations go beyond the limits that our physics and science can understand. Walk through the pages and experience what others have without any fear or doubts. An open mind will relax your inner spirit and expand your mind as you try and understand what others have experienced. The Ojai Valley is very spiritual, and the Native American Chumash people who lived along this California coast knew and understood this before us. This extends into La Conchita, Carpinteria, Santa Barbara, Goleta, Santa Ynez and beyond. The Channel Islands National Park has more information about the influences the Chumash people left behind and more details about Chumash life as it existed on the Channel Islands, Mescaltitlan and throughout the Central Coast of California.

There are still the unsolved beach murders and other killings that occurred in Southern California as a result of the East Area Rapist, who began his rampage in Northern California. Modern science now has DNA, although there is not yet a match. Investigators and prosecutors continue trying to uncover his identity. The FBI has joined in trying to find this most notorious killer and rapist.

"Imagination is more important than knowledge," as Albert Einstein stated many times. One may see or hear the unexplained, so let it be—c'est la vie!

CHAPTER 1
THE OJAI VALLEY

Why, then, make so great ado about the Roman and Greek, and neglect the Indian? We [need] not wander off with boys in our imagination to Juan Fernandez, to wonder at footprints in the sand there. Here is a print still more significant at our doors, the print of a race that has preceded us, and this is the little symbol that Nature has transmitted to us. Yes, this arrowheaded character is probably more ancient than any other, and to my mind it has not been deciphered. Man should not go to New Zealand to write or think of Greece and Rome, nor more to New England. New earths, new themes expect us. Celebrate not the Garden of Eden, but your own.
—Henry David Thoreau, Journals, 1852

THE CHUMASH LEGEND OF THE WIND SYCAMORE

Originally, the "Whispering Tree" was part of a sacred site following Highway 33 north toward the Ojai Valley from Ventura. In the area where the road turned off toward Foster Park and Ojai was a group of sycamore trees known as Khsho, meaning "The Sycamore." The revered tree was known as the "Wind Sycamore." The Chumash people believed that if you made a wish while standing under the tree, the wish would come true. Lovers would go to the tree and share a kiss; the tree was also known as the "Kissing Tree" or the "Wishing Tree." Relics would be placed on the

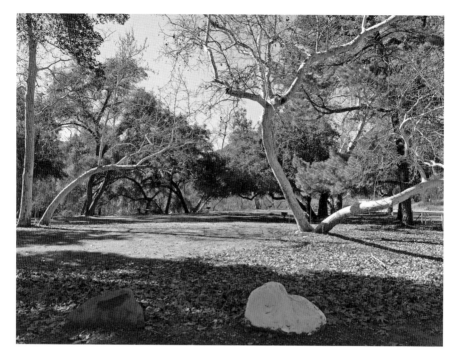

Sycamore tree in the approximate location where the Wind Sycamore once stood. *Robert G Jr.*

tree or inside of its trunk. The Chumash people revered the trees in the area. To this day, Ojai has numerous sycamore and oak trees within its city limits and beyond.

The recent discovery of the Chumash Ja'rborglyph in San Luis Obispo County illustrates the importance of trees to the Chumash people. The Spanish missionaries, recognizing the importance of this sacred site to the Chumash, located a satellite mission to the San Buenaventura called Santa Gertrudis close to the spot where the Wind Sycamore stood. The former site of Santa Gertrudis is recognized as archaeological site VEN-166. Many stories evolved around the "Whispering Tree" or "Wishing Tree." The Chumash would make a wish and leave a relic inside of the trunk. The Chumash would hang their offerings of feathers, bright cloth and skins of wild animals. A strong belief held that a wish breathed beneath the leaves of the sacred tree would come true. When later generations of lovers came to whisper their promises to each another, it became known as the "Kissing Tree."

Also hung within the hollow of the tree was a replica of a god with arms and legs. It was stated that when the people wished someone bad luck, they would turn a leg or an arm on the god in the belief that this would create a corresponding affliction on their enemy. Others named the tree Aliso del Viento, which means "Wind Sycamore" (*aliso* means "sycamore" in Spanish). Many young girls were afraid when they passed a certain tree. It was said that there was always a wind near the tree and the leaves were always rustling. If one listened intently beneath the "talking tree," the voices of ancestors could be heard. Most of the Chumash people settled within proximity to the Chapel of Santa Gertrudis. The large number of their little willow-thatched houses gave the name Casitas ("Little Houses") to the entire region. Today, there is still Casitas Springs and Lake Casitas.

After the earthquake of 1812, the entire population of San Buenaventura mission relocated to Santa Gertrudis, which was utilized as a church until 1868, when it fell into disrepair. Today, when people search for the sacred site, they travel up Highway 33 and turn left toward Casitas Vista Road, which is where part of Foster Park stood. One can see the empty land

Another example of the sycamore in the Ojai Valley. *Robert G Jr.*

and visit lush Foster Park, which is located at 438 Casitas Vista Road in Ventura, California. The Ventura River flows through this park. Voices and apparitions have been heard and seen here late at night. This area belonged to the Chumash people until they were removed and taken to the mission lands, where they were converted to Christianity.

JOHNNY CASH AND CASITAS SPRINGS

Johnny Cash moved his family to Casitas Springs in the outskirts of the Ojai Valley. He had a five-thousand-square-foot house built on a hillside overlooking the community of Casitas Springs. He planted juniper trees in his front yard, and they are still there to this day. Some have claimed that Johnny still wanders his favorite haunts in the area, for his guitar music and singing is heard in the stillness of the night. He frequented Okies Tavern in Foster Park every Saturday night when he was home and not traveling. Many do not know that Johnny moved his offices from Encino to Ventura when he made the move to Casitas Springs. He had an office in the Zander Building on Main Street in Ventura and would go there often to arrange his tours and to conduct his music business.

Johnny's four daughters, Roseanne, Kathy, Cindy and Tara, attended St. Catherine's by the Sea, and they each graduated from St. Bonaventure High School in Ventura. Their mother, Vivian Cash, provided a stable home for the girls as Johnny was traveling and recording music in the 1960s. Johnny, a man of faith, attended Avenue Community Church at 767 North Ventura Avenue in Ventura. He became good friends with Pastor Floyd Gressett. Johnny found solace there.

Vivian wrote a memoir, *I Walked the Line: My Life with Johnny*. In the book, she shares her joy and heartbreak at losing Johnny to June Carter. She tells her story in her own words.

Vivian filed for divorce in 1966, and the divorce was granted in 1967. Vivian remarried in 1968 to a Ventura Police Department officer, Dick Distin. After completing her book, Vivian passed away in May 2005.

June Carter Cash died in 2003 following complications from surgery, and Johnny Cash passed away four months later, in September 2003, from complications of diabetes.

Johnny often took his daughters to Lake Casitas or to Foster Park for picnics, or to Oak View to visit their grandparents, who were now residents

A view of Johnny Cash's former hillside home he had built in Casitas Springs. The juniper trees he planted are still growing in the front yard. *Robert G Jr.*

A vintage view of Ventura looking downtown toward the direction of the Zander Building. *Museum of Ventura County Post Card.*

Another vintage view of downtown Ventura, which beckoned many to open their businesses here, including Johnny Cash. *Museum of Ventura County Post Card.*

A popular motorcycle shop where enthusiasts gathered from nearby Ojai and Ventura. *Museum of Ventura County Post Card.*

of Oak View and managed the Johnny Cash Trailer Rancho, which Johnny had purchased for them.

Johnny lived in Casitas Springs from 1961 to 1966. He had friends in the area, including Sheb Wooley, the famous *Rawhide* actor, and Cash's Columbia Records backup singers, Johnny and Jonie Mosby. The latter two, known as "Mr. and Mrs. Country Music," lived in Ventura, where they owned the popular Ban-Dar club on East Main Street. Today, Jonie is known as Jonie Mitchell. Sheb was also known for his 1958 popular novelty song, "The Purple People Eater," and he and Johnny developed a small shopping center in Oak View known today as the Gateway Plaza. In the 1960s, Sheb owned the restaurant there known as the Purple People Eater Restaurant.

What most people do not know is that Johnny Cash was very spiritual. He believed in ghosts, having witnessed several when he lived in a second home with his wife, June Carter Cash. This home, known as Cinnamon Hill, is in Jamaica, near Montego Bay. Cinnamon Hill was a plantation property, and the house built there in 1747 survived the slave revolt of 1831. This plantation had been owned by nineteenth-century poet Elizabeth Barrett Browning. Johnny and his family spent much time on the island. Cinnamon Hill served as a sugar plantation for over one hundred years; many slaves lived in crude houses on the property. The slaves worked the fields tirelessly as indentured servants. Today, a golf course exists where the homes once stood. The remnants of the people who worked the land there are buried beneath the sod of the golf course that surrounds Cinnamon Hill. Next to Cinnamon Hill is Rose Hall, another plantation. It is rumored that the "White Witch of Rose Hall" still haunts the property. This witch's tale inspired Johnny Cash to write the song "The Ballad of Annie Palmer." Many claim that this witch haunts Cinnamon Hill, as well.

One evening, Johnny and June were hosting a small dinner party with a few guests when a white mist entered the room. All of them witnessed this apparition come through the door. It formed into the ghost of a woman. Oblivious of the guests, she walked around the dining table and through the other door to go back outside. They do not know who she was, but Johnny saw her apparition more than once, as did the maid and other members of the household. Some claim it was the "White Witch of Rose Hall."

The Cash family experienced a home invasion that lasted for four hours on the night before Christmas in 1981. Johnny and June Carter had one child together, John Carter, who was also present during the robbery. Chuck Hussey, Johnny's brother-in-law, explained that they were all sitting down at the dinner table when three assailants entered the home. They

were armed with a pistol, a knife and a hatchet. The three men rounded everyone up and locked them in the cellar. The invaders loaded all the valuables into June Carter's Land Rover and drove off, taking an estimated $50,000 in jewels, cash and other valuables. Workers from Cinnamon Hill took the Cash's other Land Rover and went to tell authorities. Later, two of the criminals were caught at the airport. They were arrested and died in police custody. The leader of this group had been killed a week before. The Cashes were safe.

They continued using Cinnamon Hill as a second home. The Jamaican people loved Johnny Cash. When he passed away in 2003, Jamaica sent an emissary to the memorial service.

After the triumphant concert at Folsom Prison, Johnny Cash was the biggest-selling artist in the country. The day after his sixty-first birthday, he was approached by Rick Rubin, a very successful rock and rap producer. He and Johnny started working on some new albums within three months, and these resulted in some of Johnny's most successful songs. Cash struggled with drugs and alcohol in various times of his life, but he was healthy during this period. His marriage to June Carter withstood trials and tribulations, and Johnny had provided for Vivian and his girls when he divorced Vivian in the late 1960s.

In June 1965, Johnny Cash went fishing in the Sespe backcountry. His truck overheated and started a fire. The blaze ravaged the Los Padres National Forest for a week, killing forty-nine endangered condors. Johnny paid $82,000 to cover the costs of the disaster once a settlement had been reached.

LAKE CASITAS

Lake Casitas is a magical place. Many throughout California have enjoyed boating activities, water-skiing and rowing here. Vivian Cash Distin, Johnny Cash's first wife, explained that Johnny wrote the song "Ring of Fire" while out on Lake Casitas one afternoon. June Carter Cash claimed credit for the song—Johnny allowed her to, since he was already in love with her. The song was a huge success. Johnny loved the outdoors, and he would go fishing with his friends on the lake. It became a favorite hangout for him.

There is another story about Lake Casitas that the locals remember. It was late afternoon when a fisherman heard rustling in the water. He was

standing on shore, surveying the scene when he looked in the direction of the water and saw a large object rise above the surface. It was spinning, and as it rose, a huge spindle of water rose with it. As quickly as it appeared, the fisherman watched the unidentified craft soar into the sky. It disappeared into the vast unknown.

A family arrived at Lake Casitas to go boating and fishing one spring day in the early 1980s. At twilight, they witnessed a large, round, yellow light descend over the area. They stood along the shoreline to observe this object, which was like nothing they had ever seen before—or since. The daughter recalls that it was silent and it hovered over them with that light overhead. What was odd was that, when they were ready to leave the area, it was already ten o'clock. But they had started packing up around seven o'clock. The family members noted the "missing time" and wondered where the hours went, because they didn't remember anything else. Others who have visited the lake have reported sightings of unidentified crafts, some of which have been described as having yellow, bluish-white or multicolored lights below the crafts. Were the family members taken aboard the spaceship? Is the missing time evidence that they were visited by aliens?

In another instance, young friends were swimming at a local pool—three young boys, ages ten and eleven, and a young girl, age twelve. The two mothers were enjoying an early evening swim with their children. The kids wanted to eat pizza, so one of the moms ordered pizza to be delivered to their location. It was 7:05 on this beautiful summer night in July 1994. The other mom happened to look up into the evening sky and spotted a circular object moving some distance to the east. This craft was circular with a bluish-white light beneath it. It looked like a full moon dancing in the air. She yelled out, "Look, look over there, there's a flying saucer, and its huge!" The other mom looked up, and both stood in awe of what they were watching in the evening sky. They know what they saw and were reluctant to tell their friends; to this day, they wonder why their pizza arrived two and a half hours late. The delivery person explained that she got lost and apologized. The moms realized that it was already 9:30 p.m., but it seemed as if only minutes had passed. Was that missing time the phenomenon that everyone refers to? They did not want to think about that.

Camp Comfort and Creek Road

Creek Road is one of the most haunted highways in California. It is a well-traveled road for drivers going from Ventura into the city of Ojai. A young college student driving home one evening took Creek Road because he was on his way to meet friends at a local restaurant in downtown Ojai. This road leads into town. As he drove his pickup truck along Creek Road, he knew he was getting close to his destination, for the highway sign read "Camp Comfort 500 feet." He was listening to music and concentrating on the lyrics as he tried singing along when suddenly, out of nowhere, popped a human-like creature approximately fifty feet ahead of him. The man, covered in leaves and twigs, was on the side of the road waving his arms, signaling for the driver to stop. The young man turned off his car stereo and turned on his high beams. The lights illuminated the man with leaves all over his body. His hair, long and full of what appeared to be twigs and leaves, resembled a bird's nest, only with long ends. The driver swerved his truck away from the "Leaf Man," who then disappeared from view. He ducked into the brush

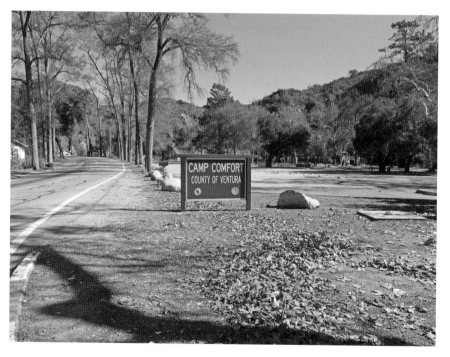

The Camp Comfort sign alongside Creek Road in Ojai, where many strange sightings have occurred. *Robert G Jr.*

and trees of Camp Comfort Park. It was a strange sighting, and the driver wondered if he really saw what he thinks he saw on the side of Creek Road.

When he arrived at the restaurant in Ojai, he breathed a sigh of relief. After all, he had nearly crashed his truck trying to avoid hitting the strange man on Creek Road. His friends had been waiting for him to arrive, so after he settled in, he asked if any of them had ever seen anything jump out of the bushes along Creek Road, or if anyone had heard of anything weird happening there. "Yes, do you have all night? We will fill you in on the weirdness of Creek Road."

The friends reminded one another of the dead body that had been found at Camp Comfort Park as recently as a few months earlier. Another reluctantly admitted that he had seen a man covered in leaves as well, but that sighting had taken place more than a year ago. The subject of "Char Man" also came up. What follows is one of the stories they told that night.

THE LEGENDS OF THE CHAR MAN

A fire ravaged the Ojai Valley in 1948, burning trees, grass, cabins and brush as it roared through the hills. According to legend, a man lived with his son alone in an isolated cabin in the hills above the Ojai Valley. This cabin, in the direct path of the fast-moving wildfire, was totally consumed by it. The father burned to death; his son, though burned, survived. Days after the blaze, the firemen arrived to survey the fire zone and devastation. As they approached the smoldering earth where the cabin once stood, they could still detect the stench of burning flesh. Behind some large boulders, they saw a burned torso and charred remains of what looked like legs. Next to these body parts sat a young man in his thirties. He, too, was burned. His face was horribly disfigured, and his arms were burned, but his legs seemed to have escaped the fire. As soon as the charred man became aware of the firemen, he jumped up and darted up the hill, away from the visitors. He disappeared into the smoldering hillside.

The firemen later testified what they had witnessed, describing the horrible scene of dried blood and burnt flesh. They described the stench as horrific. Some claim that the memory still haunts them to this day. Others who have wandered along the hiking trails near Camp Comfort or along Creek Road have witnessed a disfigured man eating berries or walking alone next to the creek. A few times when he has caught sight of strangers, he runs toward

Creek Road Bridge, where the Char Man, the Headless Motorcyclist and the Ghostly Lady of Creek Road have been seen late at night. *Robert G Jr.*

them, and they flee in fear. Visitors and travelers who hike in the area claim to have come across the "Char Man"; each has described the horrible stench of burning flesh prior to seeing him. Some claim he is searching for "fresh skin" to replace the charred skin on his face and upper body. The locals claim that "Char Man" is real and continues to wander the Ojai wilderness to this day. Beware of the "Char Man" of the Ojai Valley.

Another version of the "Char Man" legend takes place at Camp Comfort County Park. A raging wildfire burned a home near the park where a man and his disabled wife lived. Before the husband could reach his wife in her bedroom, the fire swooped down and trapped the man near his front door. He lay injured and partially burned due to his unsuccessful attempts at trying to get inside of the house. As he lay on the porch with a broken leg and burns on his arms, he could hear his wife's screams for help, but he was unable to reach her. Ultimately, the fire consumed the house and burned the wife and husband. Hikers have witnessed a burned man on the Creek Bridge walking alongside the road. If you step out onto the bridge at night, "Char Man"

will come. He will chase you as he searches for fresh flesh to replace his own and seeks his wife in order to save her. Some people have been chased during daylight hours by a man with burns on his face and upper body.

THE GHOSTLY LADY OF CREEK ROAD

As you make your way through the various hiking trails in search of locations of famous ghost haunts, be aware of the "Ghostly Lady of Creek Road." She has been seen standing alongside Creek Road near Camp Comfort. A young couple was leaving Camp Comfort Park one evening when they came across the specter of a woman standing next to the wooden bridge on Creek Road. Their headlights illuminated the ghost ahead of them. Her smoky-white dress was splattered with blood and had blotches of a reddish hue splattered on it. On seeing this, the young lady screamed. Her boyfriend quickly reacted by speeding away from the scene. They raced back to the city of Ojai to return to the city of the living. They stopped in their favorite Mexican restaurant to have dinner. Both were visibly shaken by what they had just seen on the Creek Road

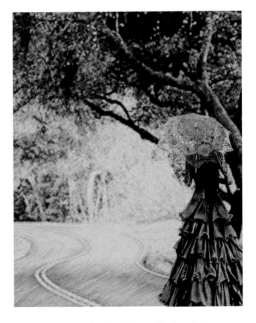

Bridge. The young lady asked the waitress if she had heard of the "Ghostly Lady of Creek Road." To her surprise, the waitress said she had.

"Yeah, my brother told me about her. He saw her one night when he was driving home and he almost crashed his motorcycle trying to swerve away from her. They say she is a girl who was murdered by her new husband on their wedding day. He killed her for her money and she haunts Creek Road and the bridge to this day."

Original illustration by Jeremy Leija of the Ghostly Lady of Creek Road. *Jeremy Leija.*

THE HEADLESS MOTORCYCLIST

Others have seen a headless motorcycle rider traveling along Creek Road very late at night. There is a story of a man who was killed while riding his motorcycle along Creek Road more than twenty years ago. Witnesses have seen him riding after midnight. More egregious than the fact that he rides without a helmet is that he does so without his head! Other nights, one hears the sounds of a motorcycle, but nothing appears. They claim that this motorcyclist had been driving too fast for the narrow highway and lost control of the bike and crashed into a tree. It was a gruesome sight, for he was decapitated. His sudden death was a tragedy for his family and friends. There are those who believe that he has unfinished business and he returns so he can finish whatever he is seeking to achieve. Others claim that while driving into Ojai at night, as they travel across Creek Road Bridge, they can hear the loud rumbling sounds of a motorcycle engine. Sometimes, they can see the faint light of a single headlight in their rearview mirror. It slowly approaches behind them, and as soon as they cross the bridge, the light disappears.

THE THREE LANTERNS

Ojai residents share a story about the ghosts of the Ojai hills. Late at night, one can see the flicker of lights of three lanterns on some of the hillsides near Creek Road. The legend is that three hikers were lost in the hills and were never found. Sandy explains that many have seen the faint flicker of three lights on several occasions along this most haunted roadway surrounded by hills and hiking trails. The observers take for granted that the lights belong to the three lost hikers trying to find their way back home. Those who live along Creek Road also hear the hooves of horses as the headless rider rides by. As the sounds are heard, no one is ever seen on the horse. It is the phantom rider and his horse. Sandy describes hearing the thundering sound of horse hooves riding along Creek Road in front of her house. When she stepped outside, she saw the shape of a rider dressed in black, but he was headless. The creature was riding a large horse. Others claim to have seen such a creature on a horse.

URBAN LEGEND OF THE VAMPIRE

There exists an urban legend that a vampire lived in the Ojai area. He relocated to the Ojai Valley in 1890 from either Spain or Italy. On his arrival in Ojai, he purchased a small ranch. Soon, cattle from neighboring ranches were turning up dead and their carcasses drained of all their blood. Many of the town's inhabitants reported seeing a wolf-like creature roaming the streets. The residents, suspecting that he was a vampire, organized and united to confront the newcomer. On the morning that they were to visit the stranger, the locals entered his property but, instead of finding their neighbor, found a stone sarcophagus. A huge dog was guarding the aboveground tomb. When the leader of the group approached the sarcophagus, the dog sprang into action and charged at him with teeth clenched and with a threatening and frightful growl. The others took off running away from the dog and the sarcophagus. The dog relentlessly pursued the group. The dog's stench hung in the air—a combination of stale sweat, dried blood and the putrid odor of rotting flesh. It was horrible.

Postcard of Ojai. *Ojai Valley Museum and Paul Harvey.*

The group's leader used the opportunity of the dog being preoccupied to break open the sarcophagus. The leader knew about secret levers and latches that could be manipulated to remove the tops of stone coffins, so he pushed here and there and, voila! The stone gave way. To his surprise, the top of the sarcophagus loosened and glided freely, revealing a dead man dressed in a black overcoat and dark clothing. The leader did not waste any time. He held up the crucifix he had brought with him in order to ward off the evil spirits, took a wooden stake from his own jacket pocket and, with a huge rock, thrust the stake through the dead man's heart. As soon as the deed was done, he replaced the stone over the tomb. He ran toward the gate at the end of the road where the crowd had gathered. As he forced his way into the crowd, he saw a lifeless dog on the ground in the middle of a group of men. The leader quickly told the group how he had thrust the stake into the man's chest and that the dog must have keeled over at the moment of his master's "death." It was the dog with the foul odor. Suddenly, the dog's lifeless body seemed to age before their very eyes. The fur transformed to a grayish-white dust. On seeing this, the people ran to the site of the sarcophagus—there was nothing there. The community was now safe from the alleged vampire neighbor and his dog, for they had both disappeared.

Nordhoff Cemetery with a view of a grave marker. *Robert G Jr.*

The legend of the Ojai Vampire is associated with a small family cemetery that later became Camp Comfort County Park. The campers who stay there claim they have witnessed many strange happenings as the sun sets. Hikers have reported seeing shadows standing along the hiking trails only to disappear when the hikers go to investigate. They hear noises along the trails—the sound of crushed leaves and twigs breaking behind them—as if someone is following them. When they turn around, no one is there. Others see movement in the brush and shrubbery, but nothing is ever found.

The Chumash mentioned the Dark Watchers in their history. The creatures were drawn on cave walls by various tribes. The Watchers are very tall "shadows" that resemble human forms. These spirits were mentioned in Robinson Jeffers's 1937 poem "Such Counsels You Gave to Me" as "forms who look human but are certainly not." John Steinbeck described the Watchers in the story "Flight" as "dark forms against the sky." Others claim to see these dark forms at twilight, standing tall against the jagged rocks on the hillsides overlooking hiking trails and campgrounds. They have also been spotted in the Santa Lucia Mountains from Avila Beach to Monterey and in the hills above Gaviota and Goleta. The Sespe Wilderness is rampant with sightings of the unexplained, tall shadow creatures.

THE TRAGEDY IN THE SESPE WILDERNESS IN 1969

The Sespe backcountry can be treacherous during a rainstorm, and it is deadly under flash-flood conditions.

Despite weather reports predicting sunshine and clear skies, a rainstorm descended on the area in early 1969, dropping more than sixteen inches of rain within a period of four days. This was the weekend a group of six adolescents decided to go target shooting and camping in the Sespe Wilderness. Robert Samples, the group leader, Bobby and Ronny Cassol, Eddie and Danny Salisbury, Frank Donato and Frank Raugh traveled into the wilderness on January 17, 1969. The Sespe Creek turned into a raging river. Another camper, Scott Eckersley of Ojai, was also camping in the backcountry. He tried to leave on January 18, but his truck got stuck in the mud. Samples did not do much better, as his truck was also stuck. Eckersley joined the group on Sunday, and on Monday, all took refuge in an empty cabin on Coltrell Flat near the Sespe Hot Springs. They intended to wait out the storm because they had enough food and a warm fire to sustain them.

At this time, a rescue party had been formed with Robert Sears, the chief equipment officer at the nearby Rose Valley U.S. Navy Seabees, deputy sheriff Chester Larson and forest ranger James Greenhill. When the rescuers reached the cabin, they explained that it would be imperative to leave as soon as possible. The rescuers told the group of boys and Mr. Eckersley that they would attempt to reach the safety of Lion camp, which is twelve miles away. Eckersley had misgivings about leaving, because they had plenty of food, the cabin provided adequate shelter and a burning fire would keep them warm. The rescuers were concerned about a second storm approaching the area. Therefore, everyone left and climbed on top of the massive, fifteen-ton bulldozer. None of the boys would make it out alive. The two rescuers and the heavy-equipment operator also lost their lives; Scott Eckersley is the only person who survived that ordeal.

Later, Scott explained that they were on the final river crossing when the freezing water of the Sespe Creek flooded out the engine on the bulldozer. It then took a half hour for the water to claim its victims; each fell off the bulldozer one at a time.

Those who have gone hiking in this area claim they have heard voices along the trails, but no one is there. Others have seen apparitions of young boys moving about the various hiking trails and nearby brush. Then these apparitions suddenly disappear into thin air.

Tate Lawyer Found

The body of missing Charles Manson case defense attorney Ronald Hughes was found in the rugged Sespe Hot Springs area near Ojai. Two Glendale men, Donald Chessman and John Wells, discovered the body while on a fishing trip eight miles below the hot springs in the Sespe Narrows, which is near the west fork of Alder Creek. Hughes represented Leslie Van Houten, one of three female defendants convicted with Charles Manson of the Tate-LaBianca murders. Hughes had gone into the Sespe area near Ojai on November 27, 1970, the day after Thanksgiving. On December 1, a call was received at the Tate trial courtroom. The caller identified himself as Ronald Hughes. He explained that he was still in the mountainous Sespe Wilderness and stuck in a flooded region. When he did not return, authorities began searching for him and Van Houten was given a different attorney. His replacement was attorney Maxwell Keith. Bill Homer explains that "Hughes

knew the communal "family" of Charles Manson months before Manson and three female codefendents were charged with murder and conspiracy.

On March 29, 1971, the jury returned death penalty verdicts against all the defendants on all counts. The Ventura County Sheriff's Rescue Unit found Hughes's body wedged between two boulders in a gorge. His body was so badly decomposed that the cause and nature of his death were ruled as "undetermined." A funeral was held on April 7, 1971, in West Los Angeles, and he was buried in Westwood Village Memorial Park Cemetery.

Acccording to Vincent Bugliosi, the author of *Helter Skelter*, Sandra Good, a close friend of Lynette "Squeaky" Fromme, claimed that Manson family members had killed "35–40 people.…Hughes was the first of the retaliation murders." Witnesses claim that Manson had open contempt for Ronald Hughes; the last thing Manson said to Hughes was "I don't want to see you in the courtroom again." That was the last time Hughes was in the courtroom, and he was never seen again.

Investigators believe Ronald Hughes died from an accidental drowning; he may have been knocked over by the swollen creek waters, hit his head and likely was swept away by the water.

In 1976, Leslie Van Houten was granted a new trial on the grounds that she was denied proper representation after Ronald Hughes disappeared. Her 1977 retrial resulted in a hung jury. She was tried again in 1978 and was convicted of the first-degree murders of Leno and Rosemary LaBianca and conspiracy in connection with the Tate murders. She was sentenced to life in prison.

MATILIJA AND WHEELER HOT SPRINGS

Locals tell of a legend about a curse the Chumash placed on the site of the hot springs. Some in Ojai assert that the curse afflicts anyone who tries to exploit the springs for commercial purposes. Various owners of the Wheeler Hot Springs have tried to turn it into a resort and spa—all have failed. The curse explicitly states that if anyone owns the land where the hot springs are located and attempts to profit by it, they would not live to enjoy their profits.

Previous owners of the hot springs areas have had bad luck and have been forced to sell the property. Fires ravaged the area in 1917 and in 1948.

OJAI VALLEY INN

Ojai, California, is a mix of artists, writers, longtime residents and those who seek privacy from Hollywood, including the late Larry Hagman, Hilary Duff and many others. Beatrice Wood, the famed artist and acclaimed "Mother of Dada," opened her studio in Ojai in 1948.

Her studio still stands today and is open to the public. The Ojai Valley is filled with lush countryside, enchanting orchards and trees. There are numerous hiking trails, and the vast Sespe Wilderness borders the Ojai Valley. Ojai is also home to the famed Thacher School. Howard Hughes attended this school, as did other notables. An alumna from Thacher explained how she enjoyed the experience there, because each freshman had to take care of his or her own horse. They had to rise by 6:00 a.m. to feed and care for the horses.

Many visitors to the Ojai Valley Inn enjoy the serene setting of the five-star luxury accommodations, the famed spa, the inn's exquisite dining and its world-famous golf course. What is not well known is the fact that the inn was built over a former Chumash village. Many Chumash artifacts were taken before laws were in place to protect Native American sites, artifacts and burial grounds. Beneath part of the Ojai Valley Inn was an Indian burial ground. There are those who claim that this is the cause for strange happenings and apparitions at the inn. There are several "haunted" rooms—Room 5 is known as being a ghostly place. Visitors have reported unexplained knocks coming from the closet and, when the closet doors are opened, an unusual smell emanates from there. The tapping sounds coming from Room 5 are unexplained, and strange voices are heard. Several housekeepers know

A view of the Ojai Valley Inn where the main entrance is located. *Robert G Jr.*

which rooms are haunted; some have claimed that when they are cleaning those rooms, items have a habit of disappearing, or they hear strange voices or noises in the room. They are alone, yet an unseen "visitor" is present. Others have seen shadow people moving inside of "empty" rooms.

NORDHOFF CEMETERY

Nordhoff Cemetery, located on the corner of Del Norte and Cuyama Roads in Ojai, is one of the most haunted cemeteries in Southern California. It was founded in 1870, and the City of Ojai took it over in 1963. Many Civil War veterans were brought to the cemetery for burial. All full burial sites are occupied, but cremation sites are still available. Ghost hunters who have explored the cemetery claim to have seen and heard a black "ghost dog" running among the grave markers. The growls are heard, only to go silent after a short time. Others have witnessed this "ghost dog" running through the cemetery before it disappears behind a large grave marker.

At night, Nordhoff Cemetery is very creepy. It was after midnight when a group of friends decided to go exploring in search of ghosts at there. The participants included two sisters, their brother and his two friends. With the absence of any moon, it was dark; it was blackness everywhere. They were dressed in warm clothes and tennis shoes and had two flashlights with them. The grass around the graves was overgrown and unkempt. It was easy to stumble over stones or bricks left out of place. As they made their way toward the taller markers, the dried leaves crackled beneath their feet; the

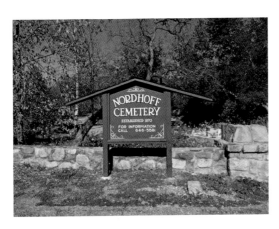

Nordhoff Cemetery sign *Robert G Jr.*

Nordhoff Cemetery, with a view looking south. *Robert G Jr.*

sounds seemed to echo everywhere. Their shadows were highlighted against the grave markers as the flashlights provided the light source. The group of teens resembled walking shadow people. Suddenly, without warning, a loud growl thundered from behind a tall marker. Someone dropped a flashlight—the light dimmed and suddenly went dark. The growling then sounded closer to them than before. They huddled together with only one flashlight left, and the boys whispered that they needed to get out of there, and fast. A foul odor whiffed through the air, and one of the girls started gagging. The guys pulled the girls as if to show them the way out, and they followed. The light was trained on the trail in front of them, and they could see it was clear and free of any large stones, for this led to the exit gate. The odor was horrible, and the teens knew it was coming from the dog. Running as fast as they could, they finally made it outside the gate. Growling sounds continued but grew distant. Finally, everything was quiet. The odor dissipated, and the growling stopped.

THE OJAI VALLEY MUSEUM

Nordhoff became Ojai (the name was changed), and the city's iconic buildings were erected beginning in 1917. The Ojai Valley Museum is currently celebrating its fiftieth-year jubilee and the City of Ojai's one hundredth anniversary. In 1993, the city purchased the historic St. Thomas Aquinas Chapel and parish hall from the Roman Catholic Church for $385,000. The chapel was originally designed by San Diego architect Richard Requa. He also designed the Ojai Arcade and Watchtower landmarks. The St. Thomas Aquinas Chapel was added to the

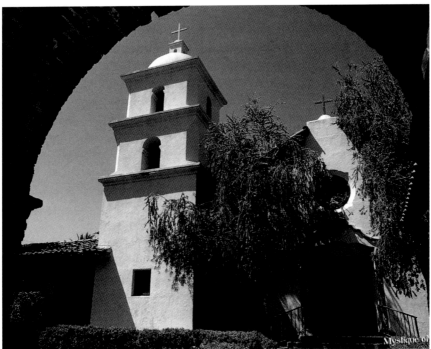

Top, left: Postcard announcing the centennial celebration of Ojai. *Ojai Valley Museum*.

Above: The church tower where the Ojai Valley Museum is now located. *Ojai Valley Museum Post Card*.

Left: Postcard view of the Ojai Valley Museum. *Linda Potter.*

Right: Front view of the Ojai Valley Museum. *Linda Potter.*

National Register of Historic Places in 1995. The Ojai Valley Museum, Ojai Valley Historical Society and Ojai Valley Museum Research Library are housed in the St. Thomas Aquinas Chapel. The museum exhibits collections of Ojai artifacts, photographs, Chumash Native American baskets and contemporary art.

OJAI NOTABLES

Among those who have called Ojai home are artists, writers, movie directors and producers, as well as Hollywood actors and actresses. Michael Kimmelman of the *New York Times Magazine* described one of these luminaries, Beatrice Wood, in the January 3, 1999 edition:

> *A disciple of the Indian philosopher Krishnamurti, she was famous for dressing in bright saris, rings on her toes, her toenails painted scarlet, walking barefoot around her house in Ojai, California....She kept copies*

Right: Vintage photo of the Ojai Arcade. *Ojai Valley Museum*.

Below: Postcard of the former St. Thomas Aquinas Church, now home to the Ojai Valley Museum. *Linda Potter*.

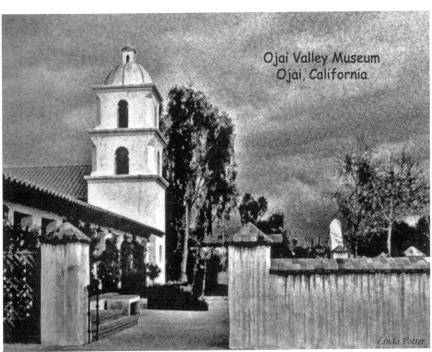

Ojai Valley Museum
Ojai, California

of her autobiography, "I Shock Myself" on a small table to sell to visitors. She befriended Brancusi, danced for Nijinsky, made costumes for Isadora Duncan and…in 1916, she met Edgard Varese…then Henri Pierre Roche…and Marcel Duchamp….Roche, Duchamp and Wood organized the Society of Independent Artists and published "The Blindman" which was a Dada Journal. This was the reason Beatrice was known as the "Mama of Dada." Anais Nin described Beatrice's pottery as "…iridescent and smokey, like trailways left by satellites.

Edward Libbey of glassware fame settled in Ojai, and Aldous Huxley helped found a school here. Jiddu Krishnamurti influenced many throughout his life, including Indra Devi, who is considered the "Mother of Western Yoga." She heard the renowned yoga master, poet and philosopher chant in ancient Sanskrit and was instantly moved. This marked a dramatic change in her life.

LA CONCHITA

They say that shadows of deceased ghosts
Do haunt the houses and the graves about,
Of such whose life's lamp went untimely out,
Delighting still in their forsaken hosts.
—Joshua Sylvester

TRAGEDY AT LA CONCHITA

On January 10, 2005, a landslide in La Conchita destroyed thirteen homes, damaged twenty-three others and caused ten confirmed fatalities. There are historical accounts of landslides in the area dating back to 1865. On this day, the mudflow washed down quickly, before any warnings could be given, and ten people lost their lives.

A man's family—his wife and three young daughters—died in that landslide. Today, there are those who claim to hear voices, crying and eerie music coming from where the homes once stood. Many residents remain living in La Conchita because of its location near the blue sea. They hope that the hillside has stabilized, and they honor the memories of those who lost their lives in the landslide. Others who remain living in La Conchita describe it as a paradise, because it overlooks the Pacific Ocean and the real estate prices are affordable. Some newcomers to La Conchita have claimed that they leave the restless spirits alone and are not bothered by any of them.

View of La Conchita and the landslide in the distance at the top of the hill. *Robert G Jr.*

A young woman described a walk she and her boyfriend took one summer night around their La Conchita neighborhood. As they walked to the end of one street where the landslide had buried some homes, they heard a faint cry. They thought it was a cat or other animal in the area. They listened once again, but all they could hear was the sound of cars passing on the freeway some distance away. This time they heard something whimpering, and all became quiet. A half moon illuminated the street, and no animals were sighted. On the way back home, they stopped at one of the local eateries to grab some ice cream. The couple saw some familiar faces in the restaurant and proceeded to ask them if they had heard about anything odd or strange near the landslide area.

"Oh, yeah! People go walking back there and get nervous and scared. They respect the area because people lost their lives under that slide, but its like visiting a graveyard. No graves are there, it just feels like one."

The young woman asked, "Does anyone ever say they hear things back there?"

"Yeah! Lots of people have said they hear crying or screams, and sometimes old music comes from where the houses used to sit against the hillside. We don't question it, we just let it be. We don't want it to happen again."

The Haunted House

The young couple continued to ask the restaurant patrons about the haunted house on the street corner where devil worshippers used to live. "You know about the haunted house here, don't you? A movie was made about this house. It used to be owned by a couple who were devil worshippers. People claim that they would sacrifice animals there. This all happened in the 1940s and 1950s," claimed an old fisherman who was sipping his coffee.

The couple heard more than they wanted to about their community. After returning home to their apartment, they took out the white sage and the sea salt they bought. It is a Native American tradition to burn sage in order to ward off any evil spirits and to use sea salt along the doorways. All of this will provide protection against evil.

They burned the sage and lined their doorways with sea salt and relaxed with cups of hot chocolate. Their view of the ocean was serene and beautiful as the ocean water shimmered beneath the moonbeams that night. This is why they remain in La Conchita.

Unexplained Activity

Neighbors know which houses people say are haunted, and they just leave the occupants alone. The occupants are often unaware they are living in a "haunted house" unless they see ghosts or experience paranormal phenomena for themselves. In one of the haunted homes, the residents describe kitchen cupboards opening and closing by themselves and objects being moved and thrown onto the floor. Lights turn on and off by themselves, and lamps move across the tables. After dark, the house is just creepy. Living there became so uncomfortable that the owners moved out and rented the place. The renters, in turn, experienced all of the unexplained events. Soon, they also moved out. All of the homes have been rented, so, somewhere along the way, the ghosts and the residents have been able to live together.

CHAPTER 3

CARPINTERIA

Our land is everything to us…I will tell you one of the things we remember on our land. We remember that our grandfathers paid for it—with their lives.
—John Wooden Leg, Cheyenne

We must protect the forests for our children, grandchildren and children yet to be born. We must protect the forests for those who can't speak for themselves such as the birds, animals, fish and trees.
—Qwatsinas (Hereditary Chief Edward Moody), Nuxalk Nation

CHUMASH LEGEND OF THE DOLPHINS

The Native Chumash people of the Barbareño-Ventureño Band of Mission Indians share stories from their ancestors. Chumash elder Julie Tumamait-Stenslie, of Ojai, has advocated for her culture's sacred sites and historical preservation. The Chumash people believe that Hutash, the Earth Mother, created the first Chumash people on the island of Limuw, which is known as Santa Cruz Island. The belief is that Hutash buried the seeds of a magical plant on Limuw, in the Santa Barbara Channel, and the people, both men and women, sprang fully grown from the plant and inhabited the island. Hutash's husband, Alchupo'osh ("Sky Snake," known as the Milky Way), sent the people the gift of fire in a lightning bolt. The people tended the fire and kept it burning so that they could cook with it and stay warm.

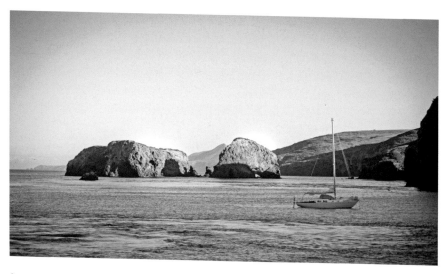

Santa Cruz Island with a boat in the distance. The Chumash used to live on the island and sail in their tomols to the mainland. *T Christian Gapen and Southland Publishing Inc.*

Julie Tumamait-Stenslie tells a story, "Chumash Story: The Rainbow Bridge," available on the Channel Islands National Park website and on YouTube. She explains that the sight of the fire attracted the Condor, whose feathers were white at the time. In his curiosity, he flew low over the fire and burned most of his feathers. They were blackened by the fire, except for a few white ones underneath the wings.

The people stayed warm. With hot food, they prospered and had healthy offspring. They soon had to leave the island due to overcrowding. Their noise kept Hutash awake at night, so she would complain to Sky Snake about the noisy people. Hutash explained that she would whisper to them to "Be quiet." They just didn't listen. She decided she would have to send the people to the mainland. She created a Rainbow Bridge for them to use to cross to the mainland.

"Hutash created a tall spanning bridge from a *Wishtoyo*, a rainbow, for the people to walk...from the tallest mountain on Limuw all the way to Tzchimoos, the tall mountain near Mishopshno." Mishopshno is now known as Carpinteria. The people were afraid that they would fall into the sea. She assured them that she would take care of them. She told them not to look down, but to look straight ahead and to keep their eye on the mainland. The people climbed onto the Rainbow Bridge and started walking toward the mainland. Families held hands as they walked. Some did look behind them, or they looked down and became dizzy. They fell into the sea. To save the

people in the water, Hutash transformed them into dolphins. They could hold their breath longer and swim from the island to the mainland shore. Today, the Chumash call the dolphins their brothers and sisters.

SANTA CRUZ ISLAND

Santa Cruz Island has an air of mystery all its own. It is the largest of the Channel Islands along the Santa Barbara Channel. The Chumash people inhabited the island for many centuries. It is part of what is known as the "North American Galapagos," because more than 150 endemic or unique species inhabit these islands. Santa Cruz Island, ninety-eight square miles, is the largest. It is forested and covered with pine trees and is home to the gray fox and to many plant species, including chamise chaparral and coastal sage, and there are many sea caves along the shore.

Among the many island fishermen, hikers and other visitors, stories have been shared over the years about ghost sightings. Christie Ranch on Santa Cruz Island is home to several apparitions. The figure of a lady in white has been seen standing on one of the cliffs on the island. She appears at night as a white fog and then disappears. It is believed that this is a young widow who died on the island from grief and heartbreak. She had married a handsome captain, and together they lived on the island in a ranch house. He had to leave one day, as his ship was sailing, but he never returned. Word reached the islanders that his ship sank and all lives were lost at sea. She lived out her final days in sadness and grief. She would look out of the windows of her house, hoping he would come home. She prayed for a miracle and restlessly walked around the island at twilight until darkness. She died on the island within a year of her husband's disappearance. Some have seen her ghost peering through the house windows or walking along the island's shore as she looks out to sea, hoping to catch a glimpse of her beloved's return.

A bridge crosses the ravine that separates the main ranch house from the workers' quarters. One night while crossing this bridge, a young servant girl began to scream. The ranch hands and the house maids ran outside to see what had happened. They found the girl crying uncontrollably. She was speaking in gibberish, and no one could decipher what she was trying to say. She wouldn't stop crying. After being taken to a mainland hospital, she passed away without ever gaining control of her senses. Whatever it was that frightened this young girl never relinquished its hold on her.

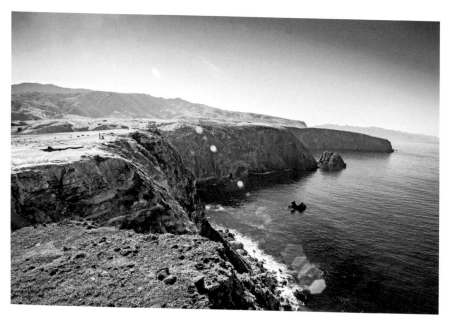

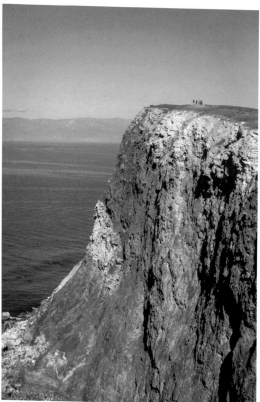

Above: View of Santa Cruz Island and one of the many coves there. *T Christian Gapen and Southland Publishing Inc.*

Left: Bluff on Santa Cruz Island overlooking the Pacific Ocean. *T Christian Gapen and Southland Publishing Inc.*

The University of California has a research facility on the island, and the Christie Ranch is a satellite used by researchers in the southwest part of the island. Today, Christie Ranch is not used to breed pigs as it was in the nineteenth century. At night, after the researchers finish their work for the day, they sit around the fire pit and share stories and experiences. Professors, graduate students and undergrads alike are reticent to discuss any sightings—until it happens to them. There have been reports of strange lights and shadows moving inside the ranch house when it is supposed to be empty. There have been the occasional odd noises late at night, but there are no explanations as to where the sounds came from or what their sources are. The ghostly apparitions are the most frightening because people have witnessed them and they cannot be explained. The unexplained sounds resonate through the trees and the earth, and the ghosts appear without warning. What are they and from where do they come? All who have heard and seen this phenomenon are believers in the spirit world.

There are sightings of ghostly happenings on Santa Rosa Island, as well. At fifty-three thousand acres in size, it is the second-largest island of the eight Channel Islands. It has served as a cattle ranch for the past one hundred years run by the Vail and Vickers families. Juan Cabrillo sailed around Santa Rosa Island in 1542, and the Chumash people greeted him while riding in their canoes, or *tomols*. Their name for Santa Rosa Island was Wi'ma, which means "driftwood."

THE GHOSTS OF SAN MIGUEL ISLAND

Juan Rodríguez Cabrillo was the first European to set foot on San Miguel Island. He and his men sailed up the California coast from Navidad, Mexico, in 1542. On the way back south after exploring Monterey Bay, Cabrillo decided he would spend the winter on the Channel Islands. He was injured; historians surmise it was probably from an attack by the local Native Americans. Juan Cabrillo was taken to San Miguel Island to recuperate, but the wound became infected, and he passed away on January 3, 1543. Legend has it that as he lay dying on the island, he cursed it and stated that anyone who tried to make San Miguel their permanent home would die a violent death.

Cabrillo's crew buried him on the island in his full armor and with his jeweled sword by his side. His coffin was placed in an unmarked gravesite,

and many treasure hunters have searched for the grave and the jeweled sword. Speculation also exists that he was buried on Santa Cruz Island or someplace in Goleta, where Mescaltitlan Island is located. No one has been successful in finding Cabrillo's grave, nor the sword.

As of today, no one lives permanently on San Miguel Island

COMMUNITY OF CARPINTERIA

There are numerous ghostly sightings along the street where the Palms restaurant is located and within the city of Carpinteria. One night in 2005, two couples were leaving the restaurant after a family dinner there, and as they walked to their car parked one block away, they witnessed a man ahead of them who suddenly walked toward a house along the way. They saw him walk through the small wooden gate, and he seemed to float to the front porch, where he disappeared. He was dressed in dark pants and a dark shirt and looked very real until he floated through the gate. The guests gasped in surprise and shock. When he disappeared in front of them, they knew they had seen a ghost. The designated driver had not had any alcohol, not even a glass of wine. Each person witnessed the same ghost. Many tales revolve around people walking and disappearing in this beachside community of Carpinteria.

Carpinteria is one of the original Chumash settlements along the California coast. Others claim that Carpinteria is a spiritual place. Numerous apparitions have been sighted here. Others claim to hear strange voices or sounds closer to the beach and shoreline.

CHAPTER 4

SUMMERLAND

Probably the scariest thing about cemeteries is that music
they play in your head when you drive by one.
—*Demetri Martin*

SPIRITUALISM AND THE BIG YELLOW HOUSE

Summerland is west of La Conchita and east of Montecito, California. Traveling up the coast on Highway 101, the beach laps at the shore and beckons each passerby with the waves and bubbly foam. One can see the Channel Islands in the distance; Anacapa Island is to the east, and next to it is Santa Cruz Island on the west side of Anacapa. The Chumash lived in this area and traveled to and from the Channel Islands on a regular basis in their canoes. Summerland itself is a euphemism for the afterlife.

Henry Lafayette Williams, a spiritualist and real estate developer, founded the town of Summerland in 1883 as a spiritualist colony. He purchased eleven hundred acres of what was once Ortega Ranch. In 1888, he divided his land into numerous tiny lots measuring twenty-five by sixty feet and sold them for twenty-five dollars each in order to populate the area with other spiritualists. The Southern Pacific Railroad had a platform stop in Summerland. In 1890, there was a bakery, a store, a schoolhouse and a library (known as Literary Hall) that was used as a dancehall. In 1894, oil was discovered in Summerland. This brought an influx of people who were

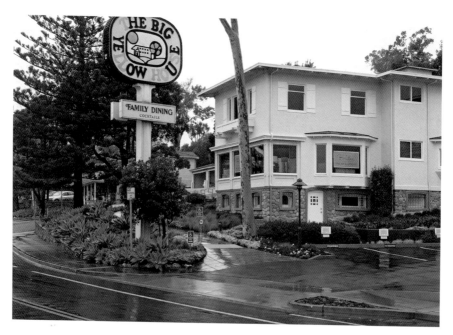

Summerland and the Big Yellow House. Séances were also held here. There is a resident ghost here, and the basement is haunted. *Robert G Jr.*

not spiritualists into Summerland, and as a result, many of the spiritualists moved to Santa Barbara. The community's center of town was a séance room, which was demolished when Highway 101 was built in the 1950s. The local spiritualist community is still alive and holds healing and worship services at the Spiritualist Church of the Comforter at their Garden Street location in Santa Barbara.

Spiritualism is the act of communicating with the dead. This is usually done through the use of a medium. Those interested in spiritualism began arriving from the East Coast in the 1880s. They settled in Summerland, which was named for the level of Heaven closest to Earth in the belief system of Theosophists. Specifically, Theosophists, Wiccans and other contemporary pagan religions give the name of Summerland to their conceptualization of an afterlife. Transcendentalists and mediums also settled in Summerland, as did people who were interested in spiritualism. Spiritualists were active in advocating for children's rights, labor reforms, religious freedom and the abolition of slavery. It has been stated that Abraham Lincoln admitted he was led to sign the Emancipation Proclamation under the guidance of spirit medium Nettie Maynard.

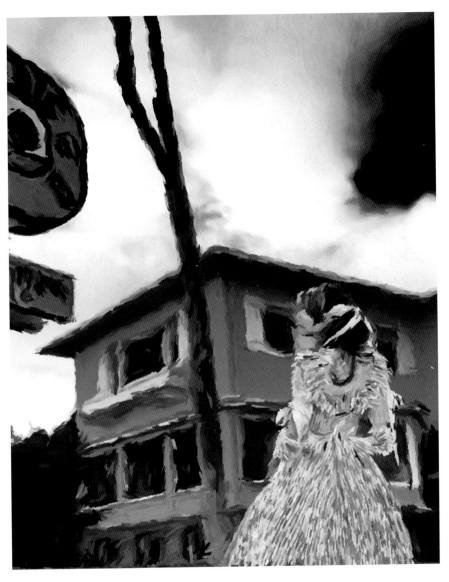

Original illustration of the Ghostly Lady of the Big Yellow House. *Jeremy Leija*.

The Big Yellow House was the scene of lively spiritualist séances and housed a restaurant for many years. In the 1970s, people often spoke about the ghostly lady seen on the second floor. Many witnessed a figure peeking out of the window, but the house was empty and no one should have been inside, since it was a restaurant at that time and was closed for the night.

Many residents and restaurant guests claim to have seen another resident spirit of the Big Yellow House. Some say they have seen a beautiful young woman in the downstairs parlor looking out of the window. She has been seen during the day as well as late at night. Others have seen her in the ladies' powder room when they look in the mirror—a woman standing beside them, her image staring back at them. She is described as wearing a long dress in the style of the early 1900s. Also haunted is the basement of the Big Yellow House. It used to be the wine cellar, and legend has it that a man was murdered there in the 1920s. His ghost has been heard late at night, for he moves boxes around in the basement and turns the lights on and off when no one is around. When the Big Yellow House served as a restaurant, many of the waiters or hostesses were afraid to venture down to the basement alone. They made it a habit to go in pairs, because the ghost would always frighten them. If there were two people, the ghost was likely to leave them alone.

ORTEGA RIDGE ROAD

It has been reported that, approximately a century ago, three nuns left the Santa Barbara Mission to take supplies, medicine and candles to some of the people in the neighboring communities. They traveled toward the eastern part of Santa Barbara and found themselves along Ortega Hill and Ortega Ridge Roads. They were tortured and murdered by a group of Chumash bandits before they reached the first settlement of people they were trying

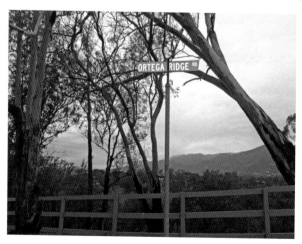

Ortega Ridge Road, where three ghosts have been sighted. The ghosts are of people allegedly murdered by bandits in the 1800s. *Robert G Jr.*

to assist. They forgave their killers before they lost consciousness. Today, these three nuns have been sighted along Ortega Ridge Road, wearing their black-and-white habits with their arms crossed as they stand on the side of the road. Witnesses have reported seeing them with white, glowing faces and bright blue eyes as they turn to watch the cars as they drive along Ortega Ridge Road.

THE TWO-STORY HOUSE AND THE BANDITS

Along the stretch of roadway known as Ortega Hill Road, sightings of a man murdered for his gold have been reported walking beside the road. His ghostly apparition appears as though he has blood stains on his shirt. When he is approached, he disappears into thin air. This man owned the two-story adobe known as the Pedro Masini House and Winery. It was built in approximately 1820 and is the oldest two-story adobe in Southern California.

1881 Article in Dec. 31 Weekly Press says a man named Gillis found Giovanni Trabucco, age 56, murdered in kitchen of Masini Adobe. He was killed on Dec 23 or 24…1882. The Weekly Press of Jan. 7 calls the crime, "The Assassination at Ortega Hill."

Romero Creek cuts through the area and is alongside the Pedro Masini House, which is the oldest two-story adobe in Southern California. *Robert G Jr.*

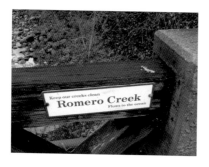

Side view of the Pedro Masini House, where the bandits took refuge before killing Mr. Trabucco for his money in the 1800s. *Robert G Jr.*

The article describes in detail the brutal wounds Trabucco received before dying. It is supposed that the murderers got between $5,000 and $6,000. There was a search for the killers, and supervisor J.M. Hunter set up a reward for the apprehension of the Trabucco murderers. Eventually, six men were arrested in June 1882 for the murder: Juan, Apolinario, Amado, Teofilo and Benito Romero, who were all brothers, and a cousin, Marcus Olivas. In July of the same year, the Santa Barbara district attorney released the accused for lack of evidence.

The novel *Ramona* by Helen Hunt Jackson describes the main character, Ramona, fleeing from Rancho Camulos on her wedding day and spending her honeymoon night at Masini Adobe. On July 7, 1992, Santa Barbara declared the site Masini Adobe Historical Landmark no. 31.

CHAPTER 5

MONTECITO

Lovers are like walking ghosts, they always haunt the spot
Of their misdeeds.
—*George H. Boker, Francesca de Rimini*

SAN YSIDRO RANCH

San Ysidro Ranch is a spiritual, luscious retreat for those who want to get away for a weekend, honeymoon or vacation or just to enjoy nature and the outdoors. It is secluded and very private, which is one of the reasons many flock to the ranch for a few nights, seeking to get away from home or just to sneak away and have a marvelous dinner in one of the two restaurants. In 1825, an adobe ranch house was built by Thomas Olivier, and it remains today as a California Historical Landmark.

The ranch was a way station and home for Franciscan monks in the late 1700s, and it became a working citrus ranch in the 1800s. In 1893, it hosted its first guests. The San Ysidro Ranch became the Johnston Fruit Company, which harvested over 300,000 oranges and over 100,000 lemons annually. A sandstone packinghouse was built in 1889 to handle the citrus production. Today, the site serves as the award-winning Stonehouse Restaurant.

A ranch house was built in 1892 that would be known as the Hacienda. This is where guests check in and sometimes gather to socialize. Sir Winston Churchill stayed at San Ysidro Ranch in the winter of 1912 with

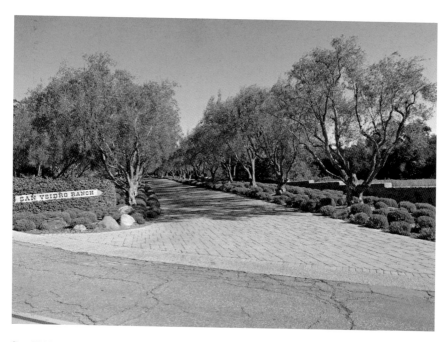

San Ysidro Ranch entrance in the luscious Montecito foothills. *Robert G Jr.*

his family. He enjoyed the weather and resort so much that he discussed the pleasant experience for years to come.

According to the San Ysidro Ranch website:

> *In the 1930's, Hollywood actor Ronald Colman and hotelier and former Senator Alvin Carl Weingand acquired the Ranch and transformed it into a hospitality haven—known for its idyllic setting...and guarding of guest privacy—for celebrities. The famous guests over the years range from Audrey Hepburn, Lucille Ball, Bing Crosby and Groucho Marx to Winston Churchill, Somerset Maugham and Sinclair Lewis. Vivien Leigh and Laurence Olivier were married at the Ranch outside in the garden. John and Jacqueline Kennedy honeymooned there and John Huston completed the script for African Queen during a three-month stay.*

Others who have frequented San Ysidro Ranch have been Gwyneth Paltrow and Chris Martin, Jessica Simpson, Sandra Bullock, Julia Roberts and Michael Douglas and Catherine Zeta-Jones. Guests have shared among themselves how the ranch represents a Shangri-La atmosphere for them. There are spirits very much alive on the grounds of the ranch. When some

guests hike the trails along the ranch's five hundred acres, they sense that someone is watching them. At other times, they hear tranquil music nearby. Many Chumash people lived in the area prior to the mission era; perhaps a Chumash shaman from the past is watching over his land. Some of the housekeepers confided to the author that they have experienced unusual happenings in some of the bungalows. Two housekeepers explained that they are not fearful of the spirits at the ranch and have grown accustomed to unusual happenings while they clean. They sense they are not alone in the rooms while they attend to their housekeeping duties. Rumor has it that the kitchen has a resident ghost, making its presence known after dark. In 1889, prior to the ranch becoming a resort, a worker lost his life in a fire in the kitchen. Many claim that he returns to make sure everything is safe and to help prevent any future fires in the kitchen.

Ty Warner purchased San Ysidro Ranch in 2000. After an extensive renovation project, the ranch maintains its acclaim as a world-class resort.

Vivien and Larry

Vivien Leigh and Laurence Olivier drove from Los Angeles to San Ysidro Ranch to marry in secret one summer night in 1940. Katharine Hepburn and Garson Kanin were traveling with them in the car; they would serve as maid of honor and best man, respectively. The ranch was owned by Ronald Colman and his wife, Benita, and Al Weingand.

It was Ronald who convinced Vivien and Larry to marry outside of Los Angeles. He encouraged them to go to San Ysidro Ranch for privacy. They could then spend their honeymoon on the Colmans' yacht out at Catalina Island off the coast of Long Beach.

Ronald and Benita helped to organize the wedding, and it was Benita who purchased the ring. Larry asked that they hold the ceremony on the terrace overlooking the mountains so they could face in the direction of England. This garden terrace is just outside the back of the Hacienda at San Ysidro Ranch. The couple performed the nuptials on August 31, 1940. Larry and Vivien had each been married to other people. After waiting four years, their divorces were final and they married in this secret ceremony.

A framed newspaper clipping hangs on the wall at the Hacienda describing Vivien and Larry's wedding. Also hanging there are black-and-white signed photos of other notables—Fred Astaire, David Niven and

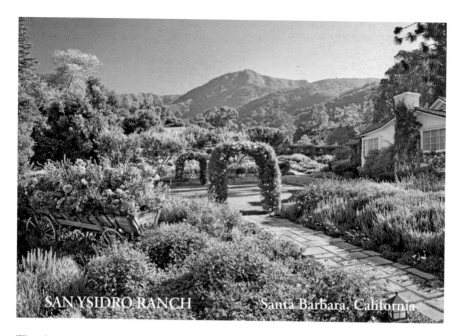

The picture-perfect postcard of the lush garden behind the Hacienda House, where it is claimed Vivien Leigh and Sir Laurence Olivier exchanged their nuptials in 1940. *San Ysidro Ranch.*

Churchill. The Stonehouse Restaurant, located in the original packinghouse, is a favorite of tourists and residents alike. The Plow and Angel, which is in the basement of the Stonehouse building, has an assortment of apparitions that make themselves known now and then. Zeta-Jones and Douglas reserve the cellar dining area on occasion as their private dining room.

JFK AND JACKIE

John and Jackie Kennedy spent their honeymoon at San Ysidro Ranch after their trip to Acapulco in 1953.

They stayed at an exclusive cottage on the property that today is known as the Kennedy Bungalow. Robert and Ethel Kennedy stayed at San Ysidro Ranch a few years later. In the late 1960s, stories circulated about various sightings of ghosts from the past in certain cottages and in the gardens of the ranch. Guests would disclose what they saw to a few of the housekeepers. One story concerned a couple returning to the Kennedy Cottage after an

A view of the Stonehouse Restaurant (*right*), which is housed in the original packinghouse. *Robert G Jr.*

The front view of the Hacienda House at San Ysidro Ranch. Adorning the walls inside are photographs and newspaper clippings of many of its famous guests. *Robert G Jr.*

afternoon hike on the ranch trail. Entering their room, they caught the sudden whiff of cigar smoke. The smoke floated in the air, and the light fog took forever to dissipate, according to the guests. Nobody else was inside the cottage. They chalked it up to a resident ghost who never left because he loved the ranch so much.

Montecito Inn, Charlie Chaplin and Fatty Arbuckle

The Montecito Inn was built by Charlie Chaplin, Fatty Arbuckle and a few friends and completed in 1928.

It is in Montecito, just two miles from Butterfly Beach. It was a welcome getaway for the Hollywood set seeking to escape the fast pace of Los Angeles. On opening night in February 1928, many stars attended, including Wallace Beery, Marion Davies, Janet Gaynor, Carole Lombard, Gilbert Roland and Norma Shearer. The inn was soon known as one of the most desirable destinations along the California coast between Los Angeles and San Francisco. In 1943, Chaplin returned to Montecito to marry the love of his

Left: View of the Montecito Inn as it looks today. *Robert G Jr.*

Right: A favorite pastime in California is to sample famous wines from the area's wineries. Montecito is a popular spot for tourists and locals alike. *Robert G Jr.*

life, Oona O'Neill. A Charlie Chaplin film library is housed at the inn, and there are glass etchings of Chaplin on the doors. Since his death, some claim to have seen him dining in the restaurant.

Montecito and Santa Barbara remain as a playground for the rich and famous. For many, it is a welcome place, because privacy is afforded to all.

FLYING A STUDIO AND FILMS IN SANTA BARBARA

Over 1,000 silent films were made at the Flying A Film Studio in Santa Barbara. The studio, located on West Mission Street, is no longer in existence. By 1916, it was producing about 242 films each year. One of the most famous stars was Mary Miles Minter, who was compared to Mary Pickford because, at fourteen, she projected sweetness and innocence. Minter made 26 films for Flying A before returning to Paramount in Los Angeles. Flying A Studio had been too cautious and did not make longer feature films. This posed many problems for the studio. It closed on July 7, 1920, a result of many top directors and other personnel returning to Los Angeles to the bigger studios, who would be making bigger films. In the meantime, Minter was involved in a sex scandal that ended her career. She was having an affair with film director William Desmond Taylor, thirty years her senior. Her mother, as well as another star, Mabel Normand, were also involved with Taylor. On the night of February 1, 1922, an assailant shot and killed Taylor in his Los Angeles bungalow. Love letters belonging to Mary Minter were found in his home, and she immediately became a suspect. Mabel was also a suspect in the murder, because both she and Minter had visited Taylor that same night. Another suspect was Mary Minter's mother, for she, too, had been having an affair with Taylor. Although the case was never solved, it ended Mary Minter's career. She is remembered with a star on the Hollywood Walk of Fame, but few of her films survived. Her last film was released in 1923, and she passed away in 1984.

THE LEGEND OF THE GRAPEVINE IN MONTECITO

Montecito, whose name means "little mountain," has tree-lined roadways similar to an English countryside. On a night in 1963, while attending an

engagement party, some of the guests decided to take a short walk around the neighborhood. They were feeling cheerful and energetic, as it had cooled down from the usual ninety-degree summer weather. The two couples walked up the road toward Mountain Drive when, straight ahead, they could see the image of a figure dancing alone against the rock wall. As they approached, the figure was not alone—another specter was with her. The witnesses could see right through both of them. The lady was wearing a long, white, gauze-type dress, and she had a shawl draping her shoulders. The figure dancing with her was a tall man. They swirled around, and it was apparent that they were dancing the tango. The staccato sounds increased in volume, and the sounds of a violin were unmistakable. All stood transfixed watching this graceful vision of swirling dancers in love. The lavender bushes provided camouflage for the group, preventing the dancers from seeing them.

The tall trees nearby seemed much taller as their shadows projected great heights against the moonlight. Orion was directly above them at this time of night, and Rigel, its blue supergiant, observed approvingly. The reverie was broken by the sudden hoot of an owl. The magic moment stood still, frozen in time. Slowly, the figures faded away against the rocks, and the music stopped.

By this time, the four witnesses, Bea, William, Laura and David, had emerged from behind the lavender and were speechless. It was time to process what they had just seen, and each one gained control of their senses and started chatting away. Bea enjoyed history, and she remembers the story her grandmother told her about the Legend of the Montecito Grapevine.

We just saw Marcelina and Carlos dancing tonight. My grandmother told me the story about how Marcelina's family did not want her to marry Carlos, and the family sent Marcelina away to Montecito. Before she left her home in Los Angeles, Carlos gave her a grapevine to plant when she reached Montecito. He told her that if it grew, then he was faithful to her and he would return to marry her. If the grapevine died, then she would be free to marry another. When she planted the grapevine, she watered it with her tears every day. It grew into the most magnificent grapevine anyone had ever seen. Carlos returned and Marcelina's parents gave their consent for her to marry Carlos, and the grapevine provided plenty of grapes for winemaking for the next hundred years. They lived a happy life here in Montecito.

Amazed, yet somewhat doubtful about what they had seen, the witnesses reluctantly accepted what they could not understand. On returning to the

engagement party, they each raised a toast to the prospective bride and groom with glasses of a favorite red wine. The mission fathers also toasted, for it was they who had produced the red wine from the plentiful grapes from the legendary grapevine.

SADAKO PEACE GARDEN AT LA CASA DE MARIA

On June 30, 2002, the Sadako Peace Garden joined the Gardens for Peace network. It was designed by landscape architect Isabelle Greene and artist Irma Cavat. The garden is a natural meditation site for reflection and inspiration for anyone who visits the Casa de Maria Retreat Center. The garden was created as a joint project of the Nuclear Age Peace Foundation and La Casa de Maria in honor of the memory of Sadako Sasaki. Sadako, a survivor of the atomic blast at Hiroshima, developed leukemia at the age of twelve, ten years after the bomb was dropped.

Sadako began folding paper cranes to regain her health and to gain world peace, based on the traditional belief in Japan that if one folds 1,000 paper cranes, one's wish will come true. At the time of her death, she had only folded 646 cranes. Her classmates folded the remaining cranes in her memory. In Peace Memorial Park in Hiroshima is a statue of Sadako. People throughout the world continue to fold cranes for world peace.

LA CASA DE MARIA

Many organizations and institutions have their groups and committees meet at La Casa de Maria Retreat House, where they have access to the beautiful gardens and conference facilities, as well as to seek inspiration.

On one of these excursions, a group of educators met for a weeklong seminar to work through curriculum standards for grades K–12 in the various school disciplines. Members of the math, social science (history), language arts and science committees were tasked with developing lessons that integrated diversity and academic projects appropriate to the age levels. At the end of the day, they were encouraged to hike or gather together and share ideas and compare notes as to which elements make for successful lessons based on grade level and age group.

When a group of teachers and administrators from several school districts in Santa Barbara decided in 1995 to venture off on a hike to explore the flora and fauna of the area, they packed their cameras, some light snacks and water. After fifteen minutes into the hike, they heard the most beautiful melody being played on a flute in the nearby wilderness. The group of educators decided to take a break and sat down under some trees. As they were sipping water and relaxing against the trees, the music sounded louder and closer to them. The music was very serene, and it seemed to lull them to sleep. Relaxation and an exchange of ideas was what they were there for, as well as to expand on their professional expertise as educators. One of the male teachers stood up from his perch against a sycamore tree and turned around abruptly and he stood facing a cluster of bushes and various plants and trees.

> *I just felt something touch my arm and I thought it was a bug or something. When I looked down, there wasn't anything there and I felt it again. It's all in my head, I suppose. Just when I was about to give up, I hear this rustling in the bushes and trees behind me. I'm going to look to see if anything is there.*
>
> *Edward was a calm type of person, and he isn't rattled very easily. His twenty years' experience as a high school science teacher has been very helpful in some tight situations.*

This time, the flute went quiet. The other educators were curious, too, so they followed Edward on the path into the bushes and trees. There wasn't anything nearby; with the exception of a few lizards, all was quiet. The group decided to head back to the retreat house in time for dinner. Edward led the way out, and the group followed. Then the music sounded, this time louder and closer. They walked out into the clearing where they had rested earlier and saw a man standing next to one of the sycamore trees, playing a flute he had fashioned from looked like bamboo. He did not see them, but continued to play. The group heard the enchanted melody, and two of the teachers started to walk over to him. But when they stepped forward, the man was gone. He had disappeared. How could that be? He was there one minute and gone the next. The group felt invigorated, but they knew that what they had seen and experienced was not of this world. The musician resembled a man in Native American dress, wearing leather skins and beads around his neck and a type of leather band around his forehead.

When the group of five returned to the retreat house for dinner, they were ready to tackle their tasks. Whatever it was they had seen and heard, it served to clear their minds and souls. They felt a new energy and a renewed sense of spirit and purpose. They finished their tasks by the end of the week and returned to their classrooms with a new sense of awareness, enabling them to be more effective educators.

THE TRAGEDY OF COUNTESS RITTER, MRS. FREDERICK HAMSCH

Countess Josephine Ritter traveled to California and purchased the Stonehedge Estate in Montecito, where she could find refuge while being estranged from her husband, Commodore Count Ritter, an officer of the German navy. She returned to Europe and divorced her husband at that time and made her way back to Montecito. Not long after she returned to the United States, she married Frederick Hamsch of New York, a member of a Wall Street brokerage firm. Their home, Stonehedge Estate, was on Hot Springs Road. It comprised fourteen acres of lush plants, gardens and riding trails. The countess was fond of horses and maintained fine stables and horses. An avid sportswoman, she enjoyed the outdoors. The former Countess Ritter was twenty-seven years of age at the time of her death in 1901. Frederick Hamsch followed her in death two years later. He died in Monte Carlo in March 1903.

The countess and Frederick entertained guests for dinner on the evening of February 7, 1901, and she spent the evening with them until 10:00 p.m., when she excused herself. She went to her room, and within moments, a pistol shot was heard. Her husband and guests rushed to Mrs. Hamsch's room, where they found her lying on the floor beside her bed. Blood was flowing from a wound in her head. Frederick rushed to her side and held her. She tried to speak, but she could not and died in his arms. Mrs. Hamsch was twenty-seven years of age.

Her husband, stricken with sudden grief, tried to revive her. He then grabbed the gun and attempted to shoot himself, but the guests wrestled it away. He had to be carefully watched, for everyone feared he would hurt himself. According to the *New York Times* of February 8, 1901, Mrs. Hamsch did not leave any clues as to why she took her life, she did not leave a note and she had not confided in anyone of her intentions.

It has been claimed that her ghost still roamed the Stonehedge Estate and that she was seen in her gardens or near the stables as well as in the house.

No one could sleep in her old room at night, because she would be seen pacing across the floor in a white gown. One former maid saw her pulling at the drapes as she stood against the glass to look outside the window. She described the see-through apparition as wearing a white gown. After the maid gasped in terror, the apparition disappeared. Frederick, the countess's widowed husband, saw her in the garden on several occasions. She was oblivious to anyone observing her; she seemed to be three-dimensional and floated above the ground. She was as beautiful as ever. She went behind a cluster of trees, and as he followed her, she disappeared. He confided in a friend that the sight of the countess was something of a comfort and that he was not frightened.

Two years after the countess's suicide, Frederick Hamsch passed away. He was heartbroken and had never been the same after his wife's death. The story is that Countess Ritter's brother Baron Louis Meyer of Monte Carlo blamed Frederick Hamsch for his sister's death, allegedly accusing him of murdering her. Others have seen a ghostlike apparition of a woman in a long flowing gown and with dark hair perfectly coiffed in the style of the early 1900s. Whether Frederick Hamsch pulled the trigger or Countess Ritter—Josephine Hamsch—committed suicide, her spirit lives on and walks along Hot Springs Road in Montecito.

FANNY VAN DE GRIFT OSBOURNE STEVENSON

Mrs. Robert Louis Stevenson (Frances "Fanny" Matilda Van de Grift Osbourne Stevenson) met Mrs. Clarence Postley (Helen Mary) in Monte Carlo in the early 1900s. Both were widows at the time and had been traveling. Mrs. Postley related the story about Stonehedge and the surrounding area of Montecito to Fanny, who was, of course, intrigued. Helen Mary shared with her the story of the ghost of the beautiful Countess Ritter and told her about the luscious Stonehedge Estate, which had belonged to her father, Captain Absalon Lent Anderson, until his death, when it was sold. Stonehedge then reverted to the family when the new owners defaulted on the property. Captain Anderson, a former Hudson River steamboat captain, lived to be eighty-four. During this time, Fanny had lived on Russian Hill in San Francisco. Her home had been designed by the architect Willis Polk, but Fanny decided she needed to find a more suitable climate. She remembered the story Mrs.

Postley had told her, so she she traveled to Montecito to see the property for herself. She fell in love with Stonehedge, purchasing the property in November 1907 for $15,000.

She sold her house in San Francisco and moved to the warmer climate of Montecito in 1908.

Fanny hired a carpenter to make structural changes and modernize the home. Fanny enjoyed gardening and planted numerous flowers and trees in her luxurious gardens. She employed Mr. Fuzisaki and Mr. Yonado to attend to her gardens, and they remained there until her death in 1914. Her two children, Lloyd Osbourne and Isobel Osbourne Strong, visited often. Fanny employed a young secretary, Edward Field, ten years her junior, who assisted her with her writing. Fanny enjoyed the social whirl of Montecito, and she hosted various receptions at the country club.

Fanny was intrigued by the story of the ghost of the beautiful Countess Ritter, as Mrs. Postley had described the story. Fanny hoped she could catch a glimpse of this legendary ghost—after all, she now owned the same house where it had been sighted.

Fanny's sister, Nellie Van de Grift Sanchez, wrote a biography of Fanny's life, *The Life of Mrs. Robert Louis Stevenson*. The book was dedicated to Fanny's daughter, Isobel Osbourne Field.

Robert Louis Stevenson passed away from a cerebral hemorrhage in 1894, and Fanny died as a result of a cerebral hemorrhage in her home at Stonehedge in 1914. The day Robert passed away, he was assisting Fanny in the kitchen in their home in Samoa. Fanny had awakened with a heavy heart and had a premonition that something was going to happen. She claims that she "knew" something was not right; everything was very unusual and out of sorts. He was preparing a salad and talking to Fanny when he suddenly touched his head with both hands. He looked at Fanny as he fell to his knees. She went to him and held him, and he lost consciousness. He died within a few hours. Stevenson was forty-four years of age. He had been in poor health throughout his life and suffered from "consumption," another word for tuberculosis. He took medications to help with the symptoms of this condition. He was recuperating when he wrote the book *The Strange Case of Dr. Jekyll and Mr. Hyde.*

It is claimed that Fanny burned the first draft of this book and that he wrote a second draft in just a few days. He claimed it was his best work. Fanny's daughter, Robert's stepdaughter, Isobel, was Robert's private secretary and assisted him in his final days. It was during the summer of 1885 at Bournemouth that John Singer Sargent painted Robert Louis Stevenson.

Fanny is seated in a chair in the portrait. The painter considered himself a very good friend to Robert Stevenson.

The book *The Strange Case of Dr. Jekyll and Mr. Hyde* became an instant success and rescued the Stevensons from their heavy debts.

On October 24, 2000, an article in the *Guardian* by John Ezard stated that Fanny's deed of tearing up the first draft "was disclosed in a two-page letter on pages torn from a notebook. It was written by her in 1885 to Stevenson's close friend and fellow poet W.E. Henley. Henley, who had only one leg, was the model for Long John Silver in *Treasure Island*. He is still known for the lines in the poem 'Invictus': 'I am the master of my fate / I am the captain of my soul.'"

It is interesting to note that Josephine Hamsch passed away or was murdered on February 8, 1901, and Fanny Stevenson passed away on February 18, 1914. Both died in the same house. After Fanny's death, her daughter Isobel Strong married her mother's former secretary, Edward Salisbury Field. They traveled to Samoa to bury Fanny Stevenson's ashes next to Robert L. Stevenson's ashes so that they could be together for eternity. Isobel and Edward moved into Stonehedge. They also lived in the other two properties Fanny had purchased in Montecito.

St. Barbara, Father Junipero Serra and the Miracle on December 4

Santa Barbara was named after the fourth-century woman who was beheaded by her father when he learned she had converted to Christianity. She is known as the patron saint of artillerymen and for anyone who works with explosives. She is also a patron saint for those in danger of sudden death in a storm, monsoon or hurricane. A friend of the author's, Diane, shared how, during World War II, her father's army regiment was being transported to Okinawa and their large ship was tossed and in danger of sinking when they came upon a monsoon. All the men went below and prayed, and those who were not Christian became believers that night, because their ship was spared and the storm calmed after everyone had prayed for nearly half an hour. They were spared, and some claimed they had offered their prayers to St. Barbara.

Father Serra, now Saint Serra, was traveling from Spain to Veracruz, Mexico, on board a Spanish galleon in 1749. The ship, *Nuestra Senora de*

Guadalupe, was hit by a storm off the shores of Veracruz and was blown off course. Father Serra gathered the other priests who were traveling with him, and they decided to pray to Saint Barbara for their physical salvation. The wind died down, the seas calmed and their lives were spared. Father Serra would later found the first nine missions of California. Santa Barbara Mission is the tenth of those missions. Father Serra died in 1784, before construction began, but his successor, Padre Fermin Lasuen, dedicated the Santa Barbara Mission on December 4, 1786 (the Feast of St. Barbara).

Before Robert Louis Stevenson wrote his book *Treasure Island*, he visited Father Serra's burial place at the Carmel Mission in California in 1879. He then wrote the story about the real Treasure Island in his book with a map dated 1750. Owen Lloyd had buried the real treasure that Jim Hawkins and Long John Silver would return to retrieve.

When Fanny returned to California and to Montecito, she enjoyed her family, friends and her devoted assistant, who was her last companion-in-adventure, Edward "Ned" Salisbury Field. Fanny's sister Nellie described the Stonehedge Estate location as "perhaps the loveliest spot on the peaceful shore of the sunset sea, under the patronage of the noble lady, Saint Barbara." Fanny died there on February 18, 1914. Six months after Fanny's death, Edward and Isobel (or Belle, as she was called) wed. They remained married until his death in 1936. He became a successful playwright and Belle an author and painter.

CHAPTER 6
SANTA BARBARA

FRANCESCHI HOUSE

Dr. Francesco Franceschi Fenzi (JD), a writer, horticulturist and environmentalist, arrived in Santa Barbara and purchased forty acres of land. The site was eight hundred feet above sea level and about two miles from the ocean. It was there that he established a botanical garden he named Montarioso, which means "airy mountain." He had a two-story residence built that was surrounded in glass in order to enable him to view the ocean and the Channel Islands. He introduced hundreds of plants from around the world to Santa Barbara's ideal Mediterranean climate. Dr. Franceschi

Gated entrance to Franceschi House and Franceschi Park. *Robert G Jr.*

Million-dollar view of the Channel Islands from Franceschi Park. *Robert G Jr.*

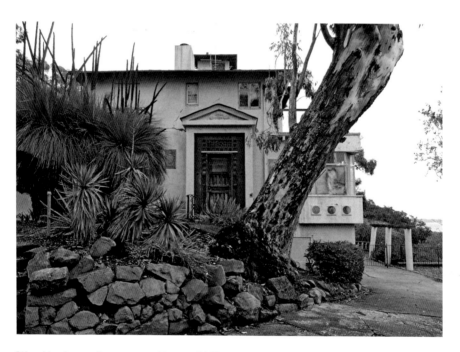

Westside view and entrance to Franceschi House. *Robert G Jr.*

introduced plants and trees to augment his new gardens, and they still thrive to this day. The drive leading up to Franceschi House is one of winding curves carved into the hillside of what is known as the Santa Barbara Riviera. The ocean views are breathtaking. Once you reach Franceschi Road, you turn right. Franceschi Park is on the left at 1501 Franceschi Road. Standing below the driveway and hillside is the majestic home that Mr. Franceschi built. Residents and tourists have seen lights turn on and off inside this vacant house and say that shadows are visible as they roam from room to room.

THE STORY OF FLORENCE MAYBRICK AND JACK THE RIPPER

Did Florence Elizabeth Chandler Maybrick really murder her husband, Jack Maybrick, by poisoning him? Was Jack *the* Jack the Ripper, as some have claimed? He was in the habit of taking arsenic and strychnine in combination because of his ailments. This was a practice he had become accustomed to following his bout with malaria. He had recovered from the disease, but not from its treatment. He was addicted to Fowler's Medicine, a popular tonic at the time, which contained arsenic.

Florence Elizabeth Chandler was born in Mobile, Alabama, on September 3, 1862. She was the daughter of William George Chandler, a former mayor of Mobile and a partner in the banking firm of St. John Powers and Company. After his death, Florence's mother married Baron Adolph von Roques, a cavalry officer in the German army. Florence met James Maybrick, a cotton merchant from Liverpool, while traveling to Britain with her mother on a cruise ship. It was a whirlwind romance and the nineteen-year-old girl spent most of her time with James, who was twenty-three years older than her. They made plans to get married and, on July 27, 1881, were wed at St. James Church in Piccadilly in London. They lived in Battlecrease House in Aigburth, a suburb of Liverpool. When she married James, Florence gave up her American citizenship.

James had not been honest with Florie, as she liked being called, for he already had several children from a mistress he continued seeing. The family experienced an economic slump, and James resigned from the Norfolk Cotton Exchange on August 22, 1884. Florie had already given birth to a son and, in 1886, had a daughter. The next year, Florie discovered that there had been another woman, Sarah Ann Robertson, in her husband's life. Sarah had been wife number one. Later in 1887, Florie met Alfred Brierly, a cotton broker with whom she had an affair.

The Maybricks hosted many dinners and parties in Liverpool. During Florie's marriage to James, they had two children. In 1887, finances were tight, and this placed a strain on the marriage, as did the fact that James had several mistresses—he had five children with one of the women. The Maybricks moved to Battlecrease House in Aigburth in 1888, but they continued having marital problems, despite sleeping in separate bedrooms. James continued with his gloomy disposition, drug addiction and hot temper. Florie suffered a black eye as a result of one of their arguments. James Maybrick became seriously ill on April 26, 1889. His health continued to deteriorate, and he saw his doctor for the last time on May 3. His health rapidly declined, and he passed away the night of May 11, 1889.

Michael Maybrick, James's brother, came to Battlecrease House and took charge of all family matters after his brother passed away. He confined Florence to her room. She was already suspected of poisoning James.

The back of Franceschi House, showing the location of Florence Maybrick's medallion (*far right, bottom middle*). *Robert G Jr.*

A commemorative plaque on the grounds of Franceschi Park. *Robert G Jr.*

These suspicions were based on rumor, not any clear evidence. But on May 14, she was arrested and charged with the crime. It was a horrible miscarriage of justice. She had purchased flypaper, but it was later determined that there was not sufficient arsenic on the flypaper to cause death. In spite of that, Florie was tried. After the jury deliberated for thirty-five minutes, she was found guilty. There was no system of appeal at that time. The trial was sensational, and she had supporters on both sides of the Atlantic, in the United States and in England. Robert Todd Lincoln, the eldest son of President Abraham Lincoln and Mary Todd Lincoln, appealed for her release. He appealed to Queen Victoria herself, but without success. Florie served a fifteen-year prison sentence and was released in 1904. The judge in Florie's murder case, Justice Stephens, passed away in 1894 in an insane asylum.

She traveled to France to visit her mother, then she returned to America. She wrote her memoirs in a book, *My Fifteen Lost Years* (1904), and she traveled to various cities to speak about her ordeal and to sell her book. It was during her visit to New Jersey for a speaking engagement that Alden Freeman met Florie. They became friends.

In 1907, Britain's Court of Criminal Appeal was introduced as a result of the Florence Maybrick case. She was responsible for prison reform, and it is this accomplishment that Alden Freeman incribed on the medallion Prison Reform dedicated to Florence Maybrick. Freeman paid for a small cottage to be built for Florie in Connecticut, and he had a monthly stipend paid to her of $150 a month until his death in 1937. Florie remained in Connecticut until her death on October 23, 1941.

JACK THE RIPPER AND THE DIARY

A diary was uncovered in 1992 written by Jack Maybrick. In it, he admits that he is Jack the Ripper.

There have been numerous "suspects" for the notorious killer. The murders occurred in the Whitechapel district in England between August 31 and November 9, 1888, always late at night. Then, for unknown reasons, the killings stopped. Each of the women murdered were mutilated and had their organs removed. The victims included Mary Ann "Polly" Nichols (August 31, 1888), Annie Chapman (September 8), Elizabeth Stride and Catherine Eddowes (both on September 30) and Mary Jane Kelly (November 9). Kelly, the last victim, was mutilated beyond recognition. To many Ripperologists, the case for Maybrick as the Ripper is a strong one, even without the diary. William D. Rubinstein, professor of modern history at the University of Wales, makes his case by explaining that James Maybrick lived alone in the center of the Ripper district and could come and go as needed. All five murders were committed on either a Friday, Saturday or Sunday. He also states that James Maybrick changed doctors on November 19, 1888—ten days after the last killing—to Dr. J. Drysdale, and he changed his treatment medications to homeopathic remedies. This helped him recover. In the diary, Maybrick wrote that he lost interest in further killings.

In Bruce Robinson's book *They All Love Jack: Busting the Ripper*, he makes the case that the Ripper was not James Maybrick, but his brother Michael Maybrick. This diary, known as "The Diary of Jack the Ripper," surfaced in 1992, when Michael Barrett produced it. The diary describes the murders in detail and was written in three acts. Michael was a very popular singer and composer in the Victorian era. A song was written in 1887 titled "They All Love Jack" and published before the Ripper killings took place. The graffiti found on the wall at the scene of one of the murders, Robinson theorizes, is a message to Charles Warren, the Metropolitan Police commissioner, that the Ripper was a Freemason. The chief inspector, Donald Swanson, was a Freemason, as was Warren. Robinson states, "I believe that Michael Maybrick was a psychopath, with a hatred of women....But I think the thing he hated almost more than women was authority, and Masonry fits very well in that authoritarian package, because every one who was in a position of authority was a Mason." Robinson also believes that Michael Maybrick was responsible for the murder of his brother James. Michael gave evidence at Florence

Maybrick's trial that helped to convict her. Robinson is certain that, by 1893, the authorities realized that Michael Maybrick was Jack the Ripper. In 1893, Michael disappeared from London society and resigned from his Masonic lodges and his clubs. He married his housekeeper, Laura Withers, and they went to live on the Isle of Wight.

ALDEN FREEMAN, THE MEDALLIONS AND GIANNI VERSACE

Philanthroper and wealthy East Coast social reformer Alden Freeman acquired the property Montarioso, known as Franceschi Park today, in 1926 from Dr. Franceschi's son and had the house adorned with plaster medallions commemorating Franceschi and other great Italian immigrants and figures from American history. Freeman purchased the surrounding acreage and donated the house and park to the City of Santa Barbara in 1931 to serve as a monument to Dr. Franceschi. The city accepted Franceschi Park and Franceschi House during the Depression, but resources were scare, and the home was not maintained. The upkeep languished over the years. Today, the house is dilapidated and in disrepair. The Pearl Chase Society is attempting to rehabilitate the house by raising funds so that the City of Santa Barbara can hold off on its demolition.

Alden Freeman's father was Joel Freeman, who was the treasurer of the Standard Oil Trust, known as Rockefeller's Standard Oil Company. Joel left Alden an immense inheritance when he passed away. Therefore, Alden retired from his career as an architect and traveled all over the world. Because Alden was a direct descendant of John Alden of the *Mayflower* on his mother's side, he had always had a genuine interest in history. Alden went to visit the Alcazar De Colon in Santo Domingo, in the Dominican Republic. This was built by Diego Columbus, Christopher Columbus's son. It is recognized as the oldest residence in the Western Hemisphere.

An example of the medallions that Alden Freeman had commissioned for Franceschi House and for his villa in Florida. *Robert G Jr.*

In 1930, Alden commissioned a house built in the Mediterranean Revival style

on Miami Beach's Ocean Drive. He named the home the Villa Casa Casuarina (after a tree native to Australia and Southeast Asia). It is rumored that Alden had a time capsule hidden in one of the walls during construction. He also commissioned a second set of medallions for this house, as he had at Franceschi House. The medallions in Miami Beach are mounted on an enclosed arcade, protected from the elements. In 1992, Gianni Versace purchased the Casa Casuarina, and it became known as the Versace Mansion. The building is part of Miami Beach's Art Deco landmark district and currently is part of an upscale restaurant and hotel.

Among the eighty-five plaster medallions are those of notables in American history, Freeman's ancestors and his contemporaries, such as Nan Britton and Florence Maybrick. Some medallions commemorate international events, as well. Emma Goldman and William Jennings Bryant have medallions, and there is one for the *Mayflower*.

As was reported in the *New York Times*, new DNA evidence confirmed that President Warren Harding fathered an out-of-wedlock daughter in

A view of Santa Cruz Island from Franceschi Park Garden. *Robert G Jr.*

Garden statue along the wall at Franceschi Park. *Robert G Jr.*

A marker on the Franceschi Park grounds. *Robert G Jr.*

1919, Nan Britton. Her fourteen-inch-square plaster medallion is placed below the front door on the level of the circular driveway. There was a "secret romance between Harding and Britton which began in 1917 while he was a senator from Ohio and continued into the White House until his death in 1923. Harding never publicly acknowledged nor saw their child, Elizabeth Ann, but supported her financially while he lived, even writing a letter of recommendation from the White House on her mother's behalf for a job with the U.S. Customs Office." Harding had never made any provision for his daughter, and she was not included in his will. Nan's mother was facing the loss of child support, and she was rejected by the Harding family, so she decided to write a book, *The President's Daughter*. This book was considered scandalous. Visitors to Franceschi Park and the house look for Nan Britton's medallion over the door.

Another medallion of importance is that of Florence Maybrick. Her medallion commemorates prison reform. As a result of her being imprisoned despite a lack of evidence, her case was the catalyst for initiating prison reform.

SANTA BARBARA MISSION AND THE MISSION CEMETERY

Father Junipero Serra died two years before the Santa Barbara Mission was established on the Feast of St. Barbara, December 4, 1786. This was the tenth of the California missions founded by the Spanish Franciscans. Father Maynard Geiger served as the archivist of the Santa Barbara Mission Research Library for many years until his death in 1977. He is buried in the Mission Santa Barbara Cemetery.

The Chumash people inhabited the coast of California from Malibu to San Luis Obispo. They were hunters and gatherers and they built their plank boats, known as *tomols*, which carried them to the Channel Islands. They created elaborate rock art located in caves and rock cliffs. Chief Yanonali, a Chumash leader, was one of many who were converted to Christianity. Many villagers joined them. The Franciscans taught the Chumash how to farm the land. The principal products were wheat, barley, corn, beans and peas. Orange and olive trees were planted, and vines were cultivated, as well. Water was brought from the mountain creeks to irrigate the fields. The aqueduct may be seen near the mission today. Cattle, sheep, goats, pigs and horses were also in abundance on the mission lands. The original

Santa Barbara Mission lavanderia and west view of the mission. *Robert G Jr.*

Santa Barbara Mission fountain on the mission grounds. *Robert G Jr.*

Front façade of the Santa Barbara Mission, known as the "Queen of the Missions." *Robert G Jr.*

Santa Barbara Mission Corridor, where the Franciscan monk has been seen. *Robert G Jr.*

purpose of the mission was to convert the Chumash to Christianity. By 1930, this was considered accomplished. Other changes then took place that compelled the Chumash population to leave the mission.

The Santa Barbara Mission is designated California State Historic Landmark No. 309. The fountain and *lavadero* are in front of the Old Mission, and the dam built in 1807 is located in the Santa Barbara Botanic Garden, a half mile up Mission Canyon.

There are numerous stories of ghost sightings at the Santa Barbara Mission and on the grounds of the mission cemetery. Some people have come face to face with a Franciscan monk in the Mission Santa Barbara Cemetery Garden. When they attempt to talk to the monk, he disappears in front of them. Others have visited the mission chapel, only to see a Franciscan monk at the altar who then vanishes. Others have been alone in the chapel and felt someone or something tap them on the shoulder and heard strange sounds, but no one is there. People claim to have seen the monk walking along the mission corridor dressed in a dark, hooded frock. When they approach him, he, too, suddenly vanishes.

JUANA, LONE WOMAN OF SAN NICOLAS ISLAND

More than five thousand people are buried in the Mission Santa Barbara Cemetery in unmarked graves. The first burial at the mission cemetery occurred on December 2, 1789. Many Chumash people are resting in the cemetery, as does the Lone Woman of San Nicholas Island. She was named Juana when she was brought to Santa Barbara. A statue was

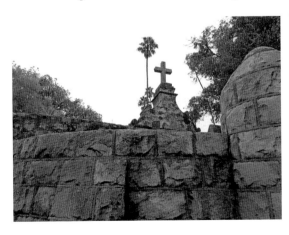

A view of the Santa Barbara Mission Cemetery. *Robert G Jr.*

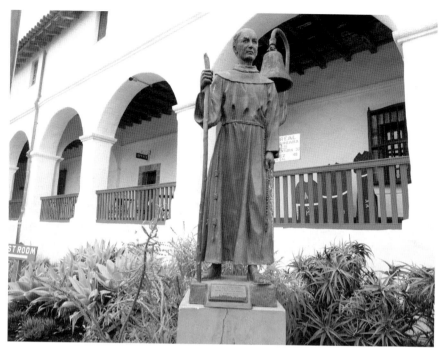

Above: Statue of Father Junipero Serra (now St. Serra). A Spanish priest and a member of the Franciscan Order, he was canonized by Pope Francis in 2015. Serra founded nine missions in Alta California. He died at age seventy at San Carlos Borromeo de Carmelo in 1784. Mission San Buenaventura was the last mission Serra founded. He passed away before Mission Santa Barbara was built. *Robert G Jr.* Saint Serra is buried beneath the sanctuary floor of Mission Carmel.

Left: Statue of Juana, the Lone Woman of San Nicolas Island, in downtown Santa Barbara. *Robert G Jr.*

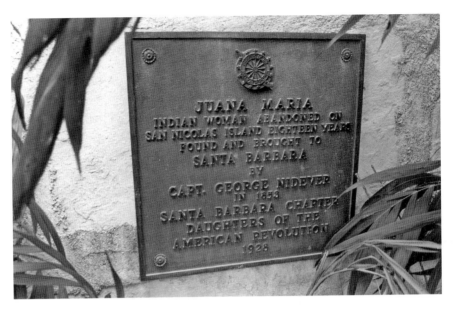

Mission plaque of Juana Maria in the Mission Cemetery. *Santa Barbara Mission Post Card.*

erected in her honor in downtown Santa Barbara and in the Mission Cemetery. When she was brought to the mainland, she lived only a year before succumbing to the white man's diseases, mainly smallpox. She was buried in an unmarked grave.

SANTA BARBARA MUSEUM OF NATURAL HISTORY

Behind the Santa Barbara Mission is the Santa Barbara Museum of Natural History. This important museum contains many Chumash artifacts and archives for research. The museum stands on land that once was home to the Chumash people. Many who have visited the museum have heard unusual voices in a language they do not understand. At dusk, people dressed in what resembles Native American dress have been seen walking through the outdoor patio. Witnesses claim the figures are not frightening and look real until they are approached, when they disappear.

DEVEREUX POINT: THE COLIN CAMPBELL FAMILY AND COAL OIL POINT

The Colin Campbell family arrived in Santa Barbara from England and tried to replicate the luxurious estate they had in Kent, so they purchased an estate along the shores of Goleta's beach. The colonel, Mr. Campbell, had a road paved from today's Storke Road and Hollister Avenue to his new ranch. Tragically, Colin Campbell was struck down by a heart attack one day before his sixty-fifth birthday in 1923.

Nancy Campbell, his wife, moved forward with the development of the estate and the completion of the main house. She hired architect Mary Craig to design the adobe main house. It had thirty rooms and eighteen baths. Mary Craig had also designed La Casa de Maria in Montecito and various other homes in Santa Barbara and Carpinteria. The garage held five Rolls Royces, and there was a tennis court and a private lake.

One party held at the estate was attended by Prince George of England, who would later ascend to the English throne. Nancy died in 1932 and was buried next to her husband overlooking the Pacific Ocean. The Celtic cross marker stood over the graves until the bodies were removed to Washington, D.C. Their son Colin Jr. took over the ranch and, in 1941, decided to close the estate. An auction was held, and many celebrities attended. Items purchased included fine china and silverware and numerous paintings and other works of art, as well as furnishings. In 1946, Devereaux School purchased the entire Campbell Ranch property for $100,000. Helena T. Devereux opened the school, known as Devereaux School. The Devereux Foundation continues to operate the center for developmentally disabled children and adults at the location. The carved granite cross that once marked the resting place for Colin and Nancy Campbell still stands overlooking the ocean.

The beach below the bluffs was the site of the unsolved murder of two young men in 1970. A third man survived. At night, many have reported seeing apparitions of two ghostly young men wandering through the property and through the forest. In addition, voices are heard. Other people have seen these specters roaming the beach below the cliffs.

HAUNTINGS ON DE LA VINA STREET, CHARLES MANSON AND BATH STREET

There are those who have lived in various older homes or apartments on De La Vina Street, only to be awakened at night from a deep slumber to the feeling that something is in their bedroom with them.

A college co-ed shared an apartment with a roommate; each had their own bedroom. One night, one of the students went to bed early because she had an exam the following day. The other girl stayed up to finish a research paper for biology. Suddenly, at midnight, there was a loud knocking on the wall coming from the kitchen. The knocking became progressively louder, and the sleeping roommate was awakened and came out of her bedroom to see what was happening. Both girls were frightened, because the knocking was now in the living room, where the girls were standing. The pounding increased. Someone was at their front door, because the doorbell rang.

After exchanging hellos, the man who lived in apartment across from them, asked the girls to please quiet down. Then the knocking stopped. The next day, the girls forgot about the incident and assumed it was a neighbor on the other end who was making the raucous—perhaps he was just putting up some pictures on his wall or working on the plumbing next door.

Charles Manson's home on Bath Street in Santa Barbara. *Robert G Jr.*

Haunted De La Vina Street sign and Cota Street. *Robert G Jr.*

Then it happened again. At midnight, the knocking resumed. This time, when the neighbor came to knock on the door, the girls let him in. He stood in their living room and heard exactly the same thing the girls did.

They were quiet and listened. Down the hallway, they saw the shadow of a man on the wall. It was moving, but there wasn't anyone there. The next day, some of their friends came over and helped to "cleanse" the house by burning sage. It seemed to help, for the apartment was quiet that night. The girls moved out the following week.

Charles Manson lived in a house on Bath Street when he resided in Santa Barbara in the 1960s. His California driver's license, posted online for anyone to view, lists his address on Bath Street. There is no evidence to link him to some of the unsolved murders that occurred in the 1960s in Santa Barbara, but there is speculation that he may have participated in a few unsolved cases.

HAUNTED THEATERS AND THE SANTA BARBARA COURTHOUSE

The Lobero Theatre is very haunted. It is home to the Lobero Ghostlight Society, and there are those who will testify to the fact that all theaters are haunted. It is a theatrical tradition to keep one lamp glowing every night after the lights go dark and the actors and theatergoers have left. The ghost light is a bulb on a lamp pole that is placed in the middle of the stage each night by the last person to leave the theater. In the morning, the light is extinguished by the first one to arrive. The tradition dates to Shakespeare's Globe Theatre. The ghost light fulfills many purposes. For one thing, it is a practical move, keeping a light on in the event that someone needs to enter at night. The other purpose is supernatural.

Jose Lobero's theater claims to have resident ghosts. These creative spirits are free to wander and roam the theater reciting their favorite lines.

One of the Lobero Theatre's actors recalls arriving one morning in 1995 to organize the costumes and props for the next production. The ghost light had been moved to stage left. It was no longer at center stage. Others have also arrived and found the ghost light somewhere else than in the center of the stage. Sometimes, faint music is heard and voices sound as though there is a group of actors rehearing their lines, but no one else is present. Items are found to have been moved and not where they had been placed the previous night. Doors open and shut by themselves. (Lutah Maria Riggs, the

The Lobero Theatre is home to the Ghostlight Society. *Robert G Jr.*

first female architect in Santa Barbara, designed the remodel of the Lobero Theater in 1922–24.)

The Arlington and the Granada Theatres are reportedly haunted, as well. The lights turn on and off by themselves, and ghostly apparitions have been seen on the stage at various times of the day. Music is heard as though the orchestra is present, then comes to a halt. In 2002, a theater director stayed late in order to finish setting up certain scenes prior to rehearsal the next day. He felt something touch his shoulder. When he whirled around to see who was there, he saw only a rack of costumes against the wall. Nothing had been disturbed. A ghost has been seen in the ladies' powder room at the Arlington Theatre. One of these sightings was very disturbing, as a group of young women who saw this ghost said she looked "normal," like a real person, but that when the women were putting on fresh lipstick in front of

the mirror, the stranger beside them was watching them. She did not have a reflection in the mirror. They could see themselves, but they could not see her—as if she were invisible. One of the women gasped in surprise, and the strange spirit turned around to leave. The women saw this stranger walk through the door to exit. They followed her outside into the hallway but did not see the strange woman.

Shadow people and ghostly apparitions have been seen walking through the corridors of the Santa Barbara Courthouse. People have felt their presence or have seen the apparitions. Cold spots exist in various locations in the halls of the building. A young couple was in the courthouse in 1998 to review some property deeds for a school project. After they finished their assignment, they decided to walk through the building, as it is quite stately and beautiful. As they walked along one of the deserted hallways, they saw a man seated on a bench about halfway down the corridor. He was dressed in dark boots, jeans and a plaid flannel shirt. When they approached him, he stared at them with such cold, dark eyes that it made the hair on their necks stand on end. Fear rushed through their veins, and they both whirled around and ran in the opposite direction. When they reached the end of the corridor, the young man turned to glance at the man sitting at the bench. This time, he was walking toward the couple.

The Arlington Theatre on State Street. *Robert G Jr.*

The Granada Theatre is one of the oldest buildings in Santa Barbara. Martha Graham, Santa Barbara native, performed here with her dance troupe. *Robert G Jr.*

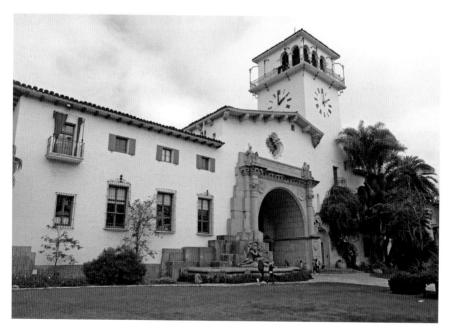

Santa Barbara Courthouse where the ghosts and specters wander the halls. *Robert G Jr.*

A corridor in the Santa Barbara Courthouse. *Robert G Jr.*

They each froze in place. The apparition's boots did not make a sound, and the couple noticed that the man seemed to be floating above the floor, gliding on air. His eyes were fixed, and he had a vacant stare—nothingness. The witnesses watched his boots as he passed. Suddenly, there was a swoosh of air, and before they knew it, the man was gone.

MURDER AT LIZARD'S MOUTH

Nicolas Markowitz was fifteen years old at the time of his death on August 6, 2000. He was kidnapped, shot nine times and then buried in a shallow grave, all because his brother's friends were looking to settle a debt. The Hollywood film *Alpha Dog* is about this murder. The leader of the group was identified as Jesse James Hollywood. According to the Santa Barbara Sheriff's Department, Nick's brother Ben, a drug dealer, owed $36,000 to Jesse. These five friends kidnapped Ben's little brother because of the

unpaid debt Mark owed to Jesse. Jesse decided it was time for Ben to pay his debt, so he had his cronies kidnap Nick and threaten to kill him so that Ben would pay up. They forcefully took Nick as he was walking near his home and drove him to Santa Barbara, where he was held captive. When Jesse gave the order to kill Nick, the group drove Nick to the Lizard's Mouth trail and shot him. They quickly buried him there. The group was captured and found guilty. Three members have been released after serving time, but another member, Ryan Hoyt, remains in prison. Jesse James Hollywood was sentenced to life without parole.

As for Ben Markowitz, he was arrested after the murder on unrelated charges and spent several months in jail. He expressed guilt for his brother's death. Ben and Nick's parents, Susan and Jeff Markowitz, are attempting to move on with their lives. Their family was shattered, and the death of their son was devastating.

Santa Barbara's Lizard's Mouth Hiking Trail is off Highway 154 on the way up to San Marcos Pass. Making a left on West Camino Cielo Road leads a traveler to Lizard's Mouth Hiking Trail. When standing next to the Lizard Rock formation, you overlook the entire city of Goleta to the ocean. It was at the foot of this hiking trail that Nicolas Markowitz lost his life. He was shot between nine and eleven times, dying instantly. He was found a few days later by hikers who followed the odor permeating the area. Nick's body was discovered in a shallow grave.

Many claim that when a person dies a violent death, they leave an imprint in the location and return to complete unfinished business. Hikers who visit Lizard's Mouth to photograph the sunset have heard strange voices along the trail or sense that someone is following them. When they look for the additional hiker, no one is found. Sometimes, a dark shadow is seen moving about the boulders. When it moves around the corner, it vanishes.

Unsolved Beach Murders

On Saturday, February 21, 1970, Sandra Garcia, twenty, who worked for the department of motor vehicles, and her fiancée John Franklin Hood, an expert marksman who had served in Vietnam and was awarded a Bronze Star, Silver Star and a Purple Heart, decided to go to the beach. They packed up food and a blanket and headed to East Beach in Santa Barbara, which is just down from Santa Barbara Cemetery. Sandra told her family

that they wouldn't be gone long and would return soon. When they failed to return, their families worried, because they always called.

The next morning, beachgoers noticed a young couple who seemed to be fully clothed lying next to each other, face down and covered by their blanket. They looked like they were asleep this Sunday morning, but there was no movement, so police were called. They were both dead. The killer had stabbed John Hood eleven times in the face and back. Sandra had suffered much worse. After the bodies were moved, investigators found the murder weapon: a bone-handled fish knife with a four-inch blade stuck in the sand. Forty-seven years later, the crime is still unsolved, and the trail of the double murder at Cemetery Beach has gone cold. Sandra was not raped, and their property was not stolen or disturbed. There has been speculation among Zodiac sleuths that all the crimes are connected. There is speculation about a possible link to Charles Manson, because he lived in Santa Barbara in the late 1960s on Bath Street.

A view along East Beach in Santa Barbara. *Robert G Jr.*

Stearns Wharf, which is just off Cabrillo Boulevard and East Beach. *Robert G Jr.*

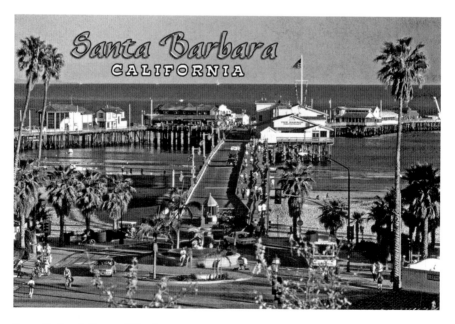

Santa Barbara's Stearns Wharf as seen on a postcard. East Beach is to the left, east of Stearns Wharf. West of Stearns is West Beach. *Robert G Jr.*

A few months after the Garcia-Hood murders, another attack occurred a few miles north. On July 5, another Sunday morning, someone walking along the beach next to the University of California–Santa Barbara, found two young men hacked to death in their sleeping bags. A third man had wounds on his head but was still alive. They watched the Fourth of July fireworks and decided to spend the night on the beach. The group was attacked with a knife and a hatchet sometime during the night. Dolan and another young man died; Thomas Hayes, nineteen, of Hermosa Beach survived.

Lompoc High School senior Robert Domingos and his girlfriend, Linda Edwards, were found murdered on a remote beach in Gaviota in 1963. It was Senior Ditch Day, and they decided to spend the day at a beach called Torry Pines. This couple is considered to be among the first victims of the infamous Zodiac Killer.

The website www.zodiackiller.com contains information about the connection police investigators have made to the Zodiac Killer. Sheriff John Carpenter announced that the Domingos-Edwards murders were being re-investigated in an attempt to link them to the known Zodiac killer of the San Francisco area, since there existed many similarities among all the murders. The 1963 murders of Domingos and Edwards happened near the Gaviota

A view of a beautiful but desolate beach. The hatchet murders took place in a secluded area near UCSB and in Gaviota in 1970. *Robert G Jr.*

Tunnel, which is just minutes away from where the other Goleta murders would occur in 1979 and 1981, for which the East Area Rapist (EAR/ONS) is the prime suspect.

SANTA BARBARA CEMETERY

The Santa Barbara Cemetery has many stories about hauntings and ghosts who reside there. People have experienced strange things at the cemetery, which is located near East Beach. Voices are heard, and shadows of people walking about are seen, but when witnesses search for the person, no one is there. The witching hour is after midnight. Visitors are bound to see ghosts or shadow people. Carbon Petroleum Dubbs was buried there in 1962. Named by his father, an oil magnate, the young boy chose to go by the initials "C.P." After C.P. married and had children of his own, he named his two daughters Methyl and Ethyl. They, along with C.P.'s wife, share the urn in the Sanctuary of Life in the Santa Barbara Cemetery.

Others buried there include Ronald Colman and Domino Harvey. On the Day of the Dead, or El Dia de los Muertos, there are those who visit the cemetery to honor the dead on November 1st, known as All Saints Day, and on November 2nd, which is All Souls Day.

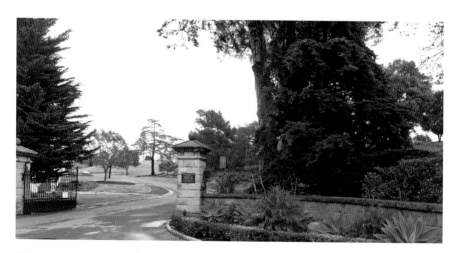

The main entrance to the Santa Barbara Cemetery, which is located along East Beach. *Robert G Jr.*

St. Francis Hospital

There are stories about a nun who has been seen pacing several floors at St. Francis Hospital in Santa Barbara.

Accounts of a former priest haunting the elevator are common. A man who was visiting his daughter was taking the elevator to the third floor. Just after the doors closed, the figure of a priest was standing next to him, having appeared within seconds. The man explained that this ghostly priest was transparent. The passenger freaked out, because the elevator had been empty when he stepped inside. The several seconds that it took to reach the third floor seemed like hours. Suddenly, the elevator stopped and the doors opened. The man stepped out as quickly as he could, and the "priest" suddenly evaporated and was gone. Others claim to have seen this figure in the elevator.

More Haunted Buildings

Santa Barbara is filled with beautiful buildings and architecture that have withstood earthquakes and the elements. More than one location boasts of resident ghosts. One of those places is the Santa Barbara High School auditorium. Many students have heard voices on stage. Yet when the sounds are investigated, no one is there. Items fall or are thrown from behind the curtains through poltergeist activity. Teenagers who have lost their lives at young ages are thought to return to the stage they loved so much. Whatever one may believe to be the reason for these incidents, it should be understood that there are no easy answers for the unexplained.

A young nurse shared her story with the author and others about a convalescent home in Santa Barbara where she used to work. She helped care for the elderly with mild dementia. One evening, after dinner, a female patient buzzed the nurse's station and stated on the intercom: "There's a man in here and tell him to leave please. He is dressed in overalls and a white shirt." The nurse went to assist the patient. When she entered the room, she did not find anyone matching that description. In fact, no one else was in the room except for the woman who had just buzzed her.

The nurse said, "Ma'am, I don't see anyone else here with you. He must have left." The resident was adamant, stating that he was tall, had

dark hair and was wearing blue overalls and a white shirt. At this point, the nurse contacted security and told them about this man who had been reported to be in one of the patient's rooms. She asked them to see if they could find him. No such man was found. A few weeks later, the resident passed away, and the room was empty

A new patient was admitted into the convalescent home a few weeks later. This man was placed in the room recently left vacated by the female resident. It was a comfortable and spacious room with a brand-new television set. After dinner that evening, the new patient buzzed the nurse's station.

It was the new patient, buzzing from the room the female resident had recently occupied. The man proceeded to say that he needed help—a stranger was in his room. The same nurse was on duty that night, and she suddenly recalled the events from the previous month. This time, she snagged the other nurse, and they both went to the room in question. After walking in, they did not see anyone except the resident.

One of them asked the gentleman to describe the stranger. He explained that he was trying to fall asleep when a tall man wearing blue overalls and a white shirt stood next to his bed, leaning over him. "I asked him to leave because I didn't know him, and he wouldn't leave. He just walked around to the other side of the bed and kept staring at me." At this revelation, both nurses calmed the gentleman. They called security and recounted the story to them.

The next day, the resident was moved into another room. The nurses keep that "haunted" room closed, because the individuals who shared their stories were so convincing and so frightened. The gentleman remained in the convalescent home for another six months and then he, too, passed on.

THE GHOST OF INOCENCIA

The legend of the ghost along Ledbetter Beach and West Beach near the harbor concerns a beautiful girl, Dona Inocencia Gonzales. Legend says that she cannot rest until she finds her lover, Rodrigo de la Guerra. Inocencia and her father, Don Luis Gonzales, lived in a large castle near the beach. He was very protective of her, because his wife had passed away and he had sole responsibility for his daughter's well-being and upbringing.

Rodrigo de la Guerra's father took his ships around Cape Horn and up and down the Mexican coast and Alta California. He traded European merchandise for skins and tallows available along the California ranchos. This occurred over one hundred years ago. Rodrigo's father would leave his son with Luis. Over the years, Rodrigo and Inocencia became very close friends, eventually growing up and falling in love.

One day, Don Luis took his daughter aside and discouraged her from falling in love with Rodrigo, because he said he could not offer her a comfortable living and did not have wealth. Rodrigo vowed that he would return a wealthy man. He asked Inocencia to wait for him, as he had one more sailing voyage to undertake. She said she would. She loved him.

Rodrigo went to Lisbon and then to Spain, where he stayed with his uncle and a cousin by adoption, Annette. She had grown up and blossomed into a beautiful woman. Annette began a devious campaign to keep Rodrigo from Inocencia. After Rodrigo became ill, he had to remain a little while longer in Spain to convalesce. He wrote letters to Inocencia, but Annette never posted them. She finally sent Inocencia a letter telling her that Rodrigo found another woman, signing it as if Rodrigo had written the letter. When Inocencia received the forged letter, she became ill and despondent. At one point, she was inadvertently left alone. She jumped off the castle tower, falling into the sea and the rocks below, where she met her death. Don Luis was beside himself with grief. He did not know of the letter and blamed himself for Inocencia's death.

The friars came to pray for Inocencia, doing so for several days. One night, during a storm, the wind blew open the shutters and heaved the tapestry that lay over the coffin into the flames of the candles. Everything was ablaze in an instant. The friars and everyone else in attendance were terrorized, because they had just seen a lady in white with floating hair waving an arm through the open shutters. Suddenly, one of the servants remembered the large quantity of gunpowder that had been moved adjacent to this room to be stored and kept safe in case it was needed. They rushed to leave before the fire consumed everything, but no sooner had most escaped when the huge rock that served as part of the foundation was destroyed and pieces hurled everywhere. Burning pieces of the building, wood and beams fell into the sea and were being washed away by the thunderous waves.

Sailors claim that on stormy nights they see a figure standing above the tallest of the rocks, looking out to sea. Rodrigo became a wanderer, for he could no longer stay at this lovely place that was part of his childhood

dreams and part of Inocencia—it had become a gravesite. The remainder of the large rock, known as Castle Rock, was removed to build the Santa Barbara Harbor, which was completed in 1930. Many have seen the ghost of Inocencia walking along the shoreline and among the rocks at night. Another specter is also seen—there are those who say it is Rodrigo.

SANTA BARBARA CITY COLLEGE

The location of Santa Barbara City College is magnificent, with views of the Pacific Ocean and the Channel Islands. In addition, a ghostly lady has been seen frequently at twilight. She walks along Shoreline Drive, where she suddenly climbs over the fence and jumps off the cliff to the ocean below. Some have observed her walking along the path parallel to the beach. She then disappears into thin air. The backstory is that she was a young girl who was murdered there sometime in the past. She returns searching for her place in the afterworld, because her death was so quick and violent.

Santa Barbara City College, home to several resident spirits. *Robert G Jr.*

The Lady in White, or the Ghostly Lady, is seen climbing the fence and jumping down to the sea below. *Robert G Jr.*

Tragedy and Hauntings in Isla Vista

David Attias, a freshman at the University of California–Santa Barbara, lived in the dorm formerly known as Francisco Torres—it has been renamed Santa Catalina Dormitory. On February 23, 2001, he plowed his turbo-charged Saab into a group of young adults in the Isla Vista coastal community that night. He killed four and permanently injured another. He then climbed onto the top of his car and declared himself the "Angel of Death."

Attias was charged with murder and, at trial, was found not guilty by reason of insanity and sent to Patton State Hospital in San Bernardino, California. On September 4, 2012, California Superior Court judge Thomas Adams granted a petition for Attias to be released from Patton State Hospital. Attias was then transferred to an "outlocked treatment program" under California's Forensic Conditional Release Program (CONREP). This initiative releases offenders back into the public who

were once deemed criminally insane if they have been deemed to have been "cured." Prosecutor Paula Waldman argued that Attias would be living among fifty-eight offenders with just four supervisors in a halfway house in a drug-infested neighborhood. She warned the court that Attias still posed a threat to society.

Attias had a history of mental health issues. When he was thirteen, he attempted to strangle his sister. As a result of this act, he spent thirty days in treatment at UCLA.

The young people and students who lost their lives in this horrific crime are not forgotten. In Isla Vista, the Attias murder rampage is known as the "Isla Vista Car Massacre." Candlelight vigils are held in remembrance of the victims at Little Acorn Park, which borders the original scene of the crime on the 6500 block of Sabado Tarde Road. The *Santa Barbara Independent* listed the names of those who lost their lives on that night in 2001: Ruth Levy, Nick Bourdakis and Christopher Divis (all twenty years old), and Ellie Israel (twenty-seven). The sole survivor was Albert Levy, Ruth's brother. Albert was left permanently disabled.

Thirteen years later, Elliot Rodger gunned down several innocent people in Isla Vista before killing himself. Prior to his rampage, he had slashed and hacked to death his two roommates and a third man in the apartment they shared. Elliot drove his black BMW coupe through Embarcadero Del Norte, Pardall Road and Segovia, all the while firing his weapons. The attack lasted eight minutes. More than five hundred rounds of ammunition had been fired. Fourteen people had been wounded either by gunshots or by being struck by Rodger's car. In the end, six people were killed, not including Rodger.

Many students have heard strange noises and cries along the streets at night, and some believe it is related to the Rodger killings. Members of this close-knit community support one another. The Isla Vista Foot Patrol continues to maintain high visibility, and university chancellor Henry Yang assisted in making changes for students so that life there is more positive and more supportive for everyone in the wake of the killings. Reports of apparitions seen outside the various apartments and in the nearby park have been cited by many residents. They are not fearful of the visions. One young lady explained that she knows the spirits must be searching, wandering and roaming the area, because this was their home.

On the night of February 25, 1970, after a year of unrest and anger, rioting students looted and set fire to the local Bank of America, which stood where Embarcadero Hall stands today. The company removed

Left: This location marks the area where students were randomly killed by a student sniper, Elliot Rodger. *Robert G. Jr.*

Below: The tragedy at Isla Vista where students were deliberately struck down by a car driven by David Attias. *Robert G Jr.*

its rebuilt bank in 1981 and replaced it with an ATM on Embarcadero del Norte. Earlier on the afternoon of February 25, William Kunstler spoke at the stadium on campus. He was one of the attorneys who had represented defendants in the well-known Chicago Seven trial following the 1968 riots at the Democratic National Convention. Those were tumultuous times.

In the wake of the bank burning, one student, Kevin Moran, was dead, accidentally killed by a policeman's bullet. Governor Ronald Reagan declared a state of emergency, and the National Guard was sent in to enforce the curfew.

Today, a commemorative plaque stands in front of the Bank of America ATM honoring Kevin Moran. It reads, "For Social Change, Fair Play and Peace."

THE LINK TO THE EAST AREA RAPIST, THE ORIGINAL NIGHT STALKER

The "East Area Rapist" has terrorized his victims, including those who survive. One of America's most horrifying serial rapists and killers, he is believed to have committed forty-five rapes and twelve murders over a span of ten years. He has never been caught and is still out there (or may be dead). He has been dubbed "East Area Rapist," "Original Night Stalker," "Golden State Killer" and "Diamond Knot Killer," explains Orange County California district attorney and investigator Erika Hutchcraft.

The killer's modus operandi was to throw the bindings to the female and tell her to bind the male, then the killer would tie up the female. According to Paul Holes, an investigator with the Contra Costa County District Attorney's office, the perpetrator then would take the female to the living room or another part of the house while the male was tied up helplessly in the bedroom. He terrorized them even more by placing some dishes or plates on the male's back and warned him that if he heard them move, he would kill the female. At some point during the attacks, he told his victims that he was going to get something to eat. They would hear him go to the refrigerator. Sometimes he would go outside on the patio to eat. He would remove something from the home to remember the victims. According to Hutchcraft, "Sometimes photos would be torn in half and he would take half the photo. He's able to prolong that crime by messing with the victim." It has been claimed that he may have been a painter and

knew the area where he murdered his victims from having worked in their neighborhoods. Paint chips were found at crime scenes.

On October 1, 1979, a couple from Goleta survived an attack from a man believed to be the Golden State Killer.

In late December 1979, a couple was found murdered in their home on Avenida Pequena in Goleta. Alexandria Manning, a thirty-five-year-old psychologist from Santa Maria, and forty-four-year-old Dr. Robert Offerman were found murdered, shot multiple times. More victims followed.

Lyman and Charlene Smith were found murdered in their home on High Point Drive in Ventura. They had died on March 13, 1980. Their wrists were bound with drapery cord using a diamond knot. The suspect became known as the Diamond Knot Killer. Journalist Colleen Cason wrote a twenty-six-part "Silent Witness" story about the Smith murders for the *Ventura County Star*, and she was featured on the E television network for a 2009 segment titled "The Original Night Stalker." The "silent witness" is the semen the killer left behind. Because of advances in technology, his DNA evidence is in the criminal database, unfortunately, without a corresponding name.

Cason wrote about the 1980 crime in the *Star*:

> *They had been found bound and bludgeoned in the bedroom of their hillside Ventura home in March 1980. A high-flying power couple, the Smiths were waiting to hear if Lyman would be appointed to the Superior Court bench when the killer struck....Genetic material he left at the Smith crime scene has been linked to four homicides in upscale Orange County neighborhoods in the 1980's and to as many as 50 vicious rapes in Sacramento in the 1970's—when he was known as the East Area Rapist. His M.O. ties him to 112 burglaries in Visalia in the early '70s and four murders in Goleta in the early '80s. Today he is known as the Original Night Stalker or ONS. Although law enforcement has his DNA profile, it is not yet linked to his real name. His crimes appeared to have stopped in 1986.*

In July 1981, about a year and a half later, Cheri Domingo, thirty-five, and Gregory Sanchez, twenty-eight, were found bludgeoned and shot to death in their home on Toltec Way in Goleta.

The attacker started his crime spree in Sacramento in June 1976, and the last crime associated with him occurred in 1986, when a woman was

High Point Drive has a beautiful view. In a home on this street, Lyman and Charlene Smith were murdered. *Robert G. Jr.*

sexually assaulted and killed in Irvine in Southern California. Marcos Breton writes on June 21, 2016, that the FBI launched a national media campaign; a comprehensive website has been set up that includes victim testimonials and a recorded message from the suspected rapist. Their hope is to breathe some life into this cold case and catch the killer. The FBI also partnered with Sacramento law enforcement to offer a $50,000 reward for information leading to his capture.

The East Area Rapist has been described as strong, physical, methodical, athletic, elusive and intelligent. There is evidence that he exhibited military precision in the way he quickly tied victims. Some of the male victims were forced to lay motionless as their wives were raped in the next room.

This elusive killer is believed to be white, around six feet tall, with blonde or light brown hair. He would be between sixty and seventy-five years old today. He could be prosecuted for the murders he is suspected of committing in Southern California, but he could not be prosecuted for the rapes he committed in Sacramento County, since the statute of limitations for rape is ten years. On September 28, 2016, Governor Jerry

Brown signed the Justice for Victims Act (SB 813), which eliminates the statute of limitations for rape in California. State senator Connie Leyva introduced the bill, and there is now a shift in policy and public perception about how rape will be prosecuted.

THE UNSOLVED MURDER OF KYM MORGAN

Kym Morgan was twenty-four years old when she met her killer in a parking lot in Santa Barbara. It was April 28, 1985, and Kym had placed an ad in a local paper stating that she was seeking a room in exchange for doing light chores. A man searching for aluminum cans found her dismembered body on East Camino Cielo Road.

Detectives believe it could be the work of a serial killer. Witnesses describe a man who was much shorter than her, perhaps five feet, six inches tall (she was six feet). He was seen getting out of a car with a white top and a blue body, and shoppers recall a gold license plate with dark blue letters, perhaps from Oregon. He had to convince her to trust him, because when Kym was nineteen, a man abducted her from a Los Angeles disco, beat her and raped her and left her for dead. It took four months in the hospital for Kym to learn to talk, walk and eat again. She had amnesia but finally recovered. Kym became a victim again, but this time, she did not live to tell about it. Her killer has not been found.

People have commented that certain areas along East Camino Cielo have negative energy. People say that they feel they are not alone there. Some claim there are resident spirits along East Camino Cielo and along West Camino Cielo, as well. Lizard's Mouth Trail is along West Camino Cielo. At the foot of that trail is the location where Nicolas Markowitz was murdered on August 9, 2000.

MESCALTITLAN ISLAND

The first Europeans to see Mescaltitlan Island were members of the Cabrillo Expedition in 1542. At that time, the island comprised more than sixty-four acres and was known as He'lo. There were hundreds of natives living on the bluffs of the bay; it was considered to be the largest single settlement along

the coast of California. The Portola Expedition passed through Goleta in 1769. Traveling with the expedition were two Catholic priests who were planning to Christianize the native peoples. Father Juan Crespi recorded in his journal all of his observations, and he drew maps of the island and the shoreline. This expedition named the large island Mescaltitlan. The explorers estimated that thousands of Chumash made their home in the area. Later, the Chumash were relocated to missions or escaped, eventually succumbing to the white man's diseases.

SANTA BARBARA MUNICIPAL AIRPORT

Today, the Santa Barbara Municipal Airport is reportedly haunted by several ghosts. Travelers have experienced lights turning on and off by themselves in the airport restrooms and in the main building. Unexplained knocks on the walls have been heard. One couple reported in 2002 seeing a man and woman in what appeared to be Chumash or Native American dress walking outside near the parking lot. When the couple rounded the corner, the mysterious people were gone.

Objects have been known to disappear from the counters, only to show up elsewhere within the vicinity of the airport. Sometimes, luggage is left behind, and its owner states that he distinctly remembered checking it in. When the luggage is found, it is returned to the tourist. Several tourists, as recently as 2013, have described the lights turning on or off in the ladies powder room or in the lobby with no logical explanation.

In 1941, the U.S. Army Corps of Engineers leveled Mescaltitlan Island to provide fill for what is now Santa Barbara Airport. The island was a historical and archaeological landmark, as it used to house more than two hundred Chumash thatched houses. Malcolm Gault-Williams writes about this in his book *Don't Bank on Amerika*. He writes, "When Tom Stork and a few of his friends decided to put an airport in the slough, they found that they were going to have to raise the level of the land by 9-12 feet, so the Corps of Engineers put their bulldozers to work and removed 75% of Mescaltitlan Island."

It is also well known that when the U.S. Army Corps of Engineers was working on this fill, it unearthed so many bones from the area of Mescaltitlan Island that the locals referred to it as Skeleton Island. There had been a sacred burial ground near the Chumash thatched homes, as well, so it

makes sense that part of this area was unknowingly unearthed and used for the Santa Barbara Municipal Airport. This airport served as a Marine Corps air station and training base during World War II. The U.S. Marines base contributed to the size of the airport as it is today and contributed to the location of the University of California–Santa Barbara. The people of Goleta and the surrounding area welcomed the marines, because the Japanese attack on Ellwood Beach was still fresh on their minds, and they knew the marines would protect the area.

THE PAINTED CAVE

Also in the area is the Painted Cave, which houses many petroglyphs along the rock façades inside the cave. According to scientists, the drawings represent a solar eclipse that occurred on November 24, 1677. The black disk is the sun, and the two red disks below the black disk are Mars and Antares. It is believed that the drawings were made for religious reasons by a shaman or a Chumash priest. Other figures painted in the cave were drawn before that date, and some were drawn after that date. The black paint came from either manganese oxide or charcoal, the red paint was made from hermatite or red ochre, and the white paint came from gypsum or diatomaceous earth. Many visitors and hikers can see the glyphs through the iron gate that was installed to protect the paintings and the cave. Mysterious flute music can be heard coming from inside the cave. This has led many to believe that the cave is inhabited by ghosts and spirits from the past. Others have seen apparitions near the cave. These ghostly figures disappear when they are noticed.

It has been said that this cave was used as a hiding place for a Native American who had led an uprising against the Spanish Missionaries before he was captured and executed. Dark shadows have also been seen lurking inside the cave walls. It is a spiritual place; people often claim they go there to find peace. When a small group of three college students from UC Santa Barbara hiked up to the Painted Cave, they saw a man in Native American dress, wearing skins and beads. He was barefoot. The men thought there had been a ceremony commemorating the Chumash people, so they did not think twice about what they saw until they found themselves alone at the Painted Cave. Smoke was emanating from inside the cave, and they could hear someone chanting. A low drone of an unfamiliar language

sounded through the area. They called into the cave, but no response came back. They could see a shadow of a person moving around. It made its way to the entrance where the young men were standing. It was the same man they had seen earlier. He walked right through the gate and right through them.

EDIE SEDGWICK AND THE SEDGWICK RESERVE

It's not that I'm rebelling. It's that I'm just trying to find another way.
—Edie Sedgwick

Edie Sedgwick

On November 15, 1971, Edie attended a reception and fashion show at the Santa Barbara Museum of Art for fashion designer Michael Novarese. She was also recorded on tape for a segment of the television program *An American Family*. This would be her last interview. After the reception, there was a party honoring Michael Novaresse that Edie attended, and she was later joined by her husband, Michael Post. At the party, another guest started verbally attacking Edie and embarrassing her in front of the crowd. The guest shouted verbal insults and allegations against her character. The host asked the abusive guest to leave, and that person was removed from the scene. Edie and Michael returned home to their apartment on De La Vina and Quinto Streets about 1:00 a.m. When Michael woke up at 7:30 a.m., he found Edie lying dead next to him. It was November 16, 1971, and she was twenty-eight years of age. The coroner registered her death as "accidental/suicide" and the cause was "acute barbiturate intoxication." She is buried at the Oak Hill Cemetery in Ballard, California. When her mother passed away in 1988, she asked that she be buried with her daughter.

Edie has been memorialized in books, songs, the poetry of Bob Dylan and Warhol's underground films. Hollywood's take on Edie as a fashion icon was the film *Factory Girl* starring Sienna Miller. Edie, a product of Santa Barbara, has become permanently preserved in the minds of all who read about her or who knew Edie Sedgwick Post. It is unfortunate that many of the descriptions about Edie do not touch on her kindness and tender, sweet nature.

She was a very loving, trusting and naïve person. She was home-schooled and had access to the best private tutors, yet she did not know the ways of the world. She was at a disadvantage, because she trusted those who were kind to her. She never considered the possibility that those people could have ulterior motives. She went through her $80,000 trust fund in six months in New York City. Perhaps with strict guidance and direction, this may not have happened.

She was a child of the 1960s, and this, too, is a factor—it was a decade without rules. It was the era of the women's movement, with all the trappings to go along with that. Personal exploration was encouraged, as were sex, drugs and rock 'n' roll.

A former Santa Barbaran described Edie when she met her in 1971, "When you met Edie, you were energized instantly. She had that sparkle and spontaneity for life and fun. She expressed herself honestly and not in a pretentious way—not ever pretentious. She was kind and so sweet. You knew that you mattered to her when you were with her."

When you visit the Sedgwick Reserve and walk the trails or just enjoy the expansive vistas of the valley, think about Edie having done the same thing when she was growing up there at the ranch. The other children rode horses with her, as well. In the midst of seemingly idyllic circumstances, there existed much tragedy. Now, the Sedgwick Reserve has become a beacon and bright light for research and educational programs for the University of California, Santa Barbara. Andy Howell, adjunct professor of physics at UCSB, is one of the team leaders who discovered a supernova using a telescope at the Sedgwick Reserve. The Sedgwick Reserve Telescope enabled astronomers to identify this supernova explosion immediately after the event.

Edie wanted to be a star. Today, the Sedgwick Reserve burns bright for everyone. Francis "Duke" Sedgwick and his wife, Alice Deforest Sedgwick, purchased the 5,885 acres of Rancho La Laguna with the money from Alice's family.

Edie's Family

Edie Sedgwick was the seventh of eight children born to Francis and Alice Sedgwick. Having had three nervous breakdowns prior to his marriage in 1929 to Alice Delano De Forest, his doctor advised him against having children. But their marriage resulted in eight children: Alice "Saucie" in 1931, Robert Minturn "Bobby" in 1933, Pamela in 1935, Francis Minturn

"Minty" in 1938, Jonathan in 1939, Katharine "Kate" in 1941, Edith Minturn "Edie" in 1943 and Susanna "Suky" in 1945. If Edie were alive today, she would be seventy-four years of age. Her great-great-great-grandfather moved to Stockbridge, Massachusetts, and Judge Theodore Sedgwick (1746–1807) served as chief justice of the Supreme Court of Massachusetts. Edie's grandmother Pamela Dwight had gone insane halfway through her life. Many of Edie's relatives moved to New York after having received their education at Harvard. Francis and Alice moved from Cambridge and New York to Santa Barbara. Francis was advised to develop his artistic side, and this would help his depression and other nervous disorders. They moved to a fruit ranch in Goleta, and Edie was born at Cottage Hospital in Santa Barbara on April 20, 1943. They purchased a ranch in the Santa Ynez Valley with money Edie's mother had inherited. Then oil was discovered on the ranch. With that additional money, they purchased the six-thousand-acre Rancho La Laguna de San Francisco. This land was bequeathed to the University of California, Santa Barbara and is known today as the Sedgwick Reserve.

The Sedgwicks were educated in their own schoolhouse on the property. They rode horses and played on the tennis court and in the swimming pool built on the property. All who visited the ranch described it as having been "breathtakingly beautiful" and a Shangri-La type of place. Edie's brother Minty hanged himself the day before his twenty-sixth birthday while at the Silver Hill Hospital in New Canaan, Connecticut, in 1964. Another brother, Bobby, also had psychiatric problems and was committed to Bellevue Hospital in New York City. It is the oldest public hospital in the United States, founded on March 31, 1736. He was transferred to Manhattan State Hospital. On New Year's Eve in 1964, he crashed into the side of a bus while on his Harley-Davidson motorcycle. He was not wearing a helmet at the time. He passed away on January 12, 1965. This was heartbreaking for Edie. She was especially close to Minty, and those who knew Edie claim she never really recovered from losing Minty to suicide.

Francis "Duke" Sedgwick

Francis was a well-known sculptor, and his work is on exhibit at the Santa Barbara Mission and the Earl Warren Showgrounds in Santa Barbara, as well as in private collections worldwide. In 1967, Francis donated a

controlling interest in 5,114 acres of the ranch to UCSB with the intent that the entire property go to the university when he and his wife passed away.

After his death, Mrs. Sedgwick changed her mind and, in 1988, decided to leave her remaining interest of 782 acres to her five remaining children. In the 1990s, the Land Trust for Santa Barbara County succeeded in raising $3.2 million and acquired the land from the heirs to the Sedgwick estate. Francis Sedgwick was a very generous man. Today, the Sedgwick Reserve is used extensively for research, the arts and educational programs. Scientists from UCSB and other institutions from around the globe participate in ecological and agricultural research projects.

Andy Warhol and Bob Dylan

In spite of all of her personal issues and her hospitalizations for anorexia, all who knew Edie adored her. She was very artistic and enjoyed painting and drawing. She also sought a career in modeling. She moved to New York and lived with her grandmother in Manhattan for a time. It was in New York that she met Andy Warhol and Bob Dylan.

Edie was the "It" girl. *Vogue* magazine photographed her and labeled her a "Youthquaker." Many young women began to imitate her style: large earrings, dark eyeliner and makeup. Edie cut her hair and wore black tights and short skirts. Andy Warhol called her his "Superstar" and his "Muse." She starred in eighteen underground films that Andy produced. (Warhol never paid Edie for her work in his films.) When she met Bob Dylan, she fell madly in love with him. She confided in her brother John that she met the love of her life and he played the guitar. Dylan's *Blonde on Blonde* album is rumored to be about Edie. Andy told Edie that Bob Dylan had married Sarah Lownds. Edie was devastated.

Her father had been hospitalized at Cottage Hospital for pancreatic cancer. He passed away while Edie herself was hospitalized in New York. Francis Minturn Sedgwick, world-renowned sculptor, artist and owner of Rancho La Laguna de San Francisco, passed away at age sixty-three on October 24, 1967. Edie left the New York scene and returned home to be with her mother.

Edie met Michael Post when they were both in rehab at Cottage Hospital. He helped Edie with her medications and encouraged her to stay off certain drugs and alcohol. They fell in love and married at the ranch in June 1971. In November of that year, Edie attended a reception at the Santa Barbara

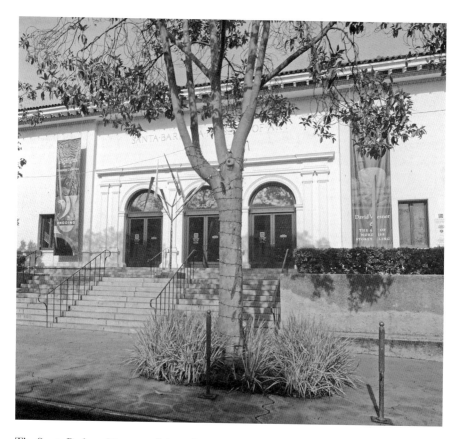

The Santa Barbara Museum of Art, where Edie Sedgwick attended a reception to honor designer Michael Novarese the night before she died. *Robert G. Jr.*

Museum of Art and she was also filmed that same night at the Santa Barbara Museum of Art for a segment of *An American Family* for television. Edie attended an after-party after the filming and reception. There, another guest had a verbal confrontation with Edie. The woman told Edie that she was a heroin addict and a junkie. The host asked the woman to leave, but the harm had been done. Edie telephoned Michael Post at home and asked him to join her at the party. She told Michael that she was upset about the incident. Michael arrived and stayed with Edie. They left the party at about 1:00 a.m. He gave Edie her prescription medication, and they went to bed. When Michael woke up at about 7:30 a.m., Edie was dead. The coroner's report states she died from an accidental barbiturate overdose.

The apartment complex where Edie Sedgwick was found dead by her husband, Michael Post, on the morning of November 16, 1971. She had been married for only about four months. *Robert G Jr.*

Manifestations

Those who have visited the Sedgwick Reserve have seen shadows moving inside what was once Francis "Duke" Sedgwick's studio.

Strange noises are heard inside the two small buildings that served as bedrooms for the children while the ranch house was being built. Visitors claim these two buildings are haunted. The house is being renovated and modernized to make it comfortable for researchers who reside there while working on projects.

The guests have witnessed a man riding his horse in the area when no one is around, and some have claimed they hear horse hooves approaching the area, but there is no one there and no horses are nearby. They hear the sounds of the phantom horses at sunset and sometimes at dawn. Laughter can be heard coming from inside the main house. There is no explanation, because there isn't anyone inside. Witnesses

claim they have seen a man riding a phantom horse. He and the horse then disappear before their very eyes. Others claim that the bunkhouse next to the original ranch house is haunted. There has been an extensive remodeling project of the ranch house; perhaps now, the apparitions will no longer be visible.

BIBLIOGRAPHY

Books

Cash, Johnny, with Patrick Carr. *Cash: The Autobiography.* New York: HarperOne, 2003.

Cash, Vivian. *I Walked the Line: My Life with Johnny Cash.* New York: Simon and Shuster, 2007.

Stein, Jean, and George Plimpton, eds. *Edie: American Girl.* New York: Grove Press, 1982.

Van de Grift Sanchez, Nellie. *The Life of Mrs. Robert Louis Stevenson; Fanny Van de Grift Stevenson.* Reprint. N.p.: James D. Stevenson, 2001.

Ybarra, Evie. *Ghosts of Ventura County's Heritage Valley.* Charleston, SC: The History Press, 2016.

————. *Legendary Locals of Fillmore.* Charleston, SC: Arcadia Publishing, 2015.

Pamphlets and Articles

Breton, Marcos. "'East Area Rapist' Still Haunts Sacramento." *Sacramento Bee,* June 21, 2016.

Cason, Colleen. "The Silent Witness: Chapter 1: Between the Sea and the Stars." *Ventura County Star,* November 3, 2002.

Closson, Rick. "The Bride of Jack the Ripper?" *Santa Barbara Independent,* December 31, 2015.

Geiger, Maynard, OFM, PhD. *Mission Santa Barbara: 1782–1965*. Oakland, CA: Franciscan Fathers of California, 1965.

Latimer, Greg. "Close Encounters at the Johnny Cash House in Jamacia." *Mysterious Destinations* (2017).

Saint-Onge, Rex W., Sr. John R. Johnson, and Joseph R. Talaugon. "Archaeoastronomical Implications of a Northern Chumash Arborglyph." *Journal of California and Great Basin Anthropology* 29 (2009): 29–57.

Stewart, Katherine. "Almost Famous," *Santa Barbara* (October/November 2006).

———."Into the Light," *Santa Barbara* (December 2008/January 2009).

Williams, Malcolm-Gault. "Don't Bank on Amerika, the History of the Isla Vista Riots of 1970." Self-published, 1987.

Museums

Channel Islands National Park
Santa Barbara Museum of Natural History
Ojai Valley Museum

Interviews

Jeannette Andrade
Hattie Beresford
Elizabeth Diaz
Linda Starnes Faris
Diane Farnsworth
Eugene Ford
Martha Gentry
Tom Hardison
Francesca C. Hunter
Kris Hyatt
Giselle Larson
Barbara Leija
Jeremy Leija
Becky Morales
Mary Samuels
Robert Ybarra

GLOSSARY

APPARITION A spectral image of a person that materializes even though a physical body is not present.

ASTRAL PLANE A world that is believed to exist above our physical world.

BANSHEE A wailing spirit or "death omen" that appears to be in two different places at the same time.

CHANNELING In this modern-day method of spirit communication, a spirit passes information directly to a medium or channeler, who will relay the information to the listener.

CLAIRSENTIENCE A general term for clairvoyance. Clairsentience occurs in the form of ESP through physical sensations or smells.

CLAIRVOYANCE An acute insight or perceptiveness that enables one to see objects or events in the form of mental imagery and intuition that cannot be perceived by the senses.

COLD SPOT An area where the temperature is several degrees lower than the surrounding area. It is believed that these are caused by ghosts or spirits attempting to manifest themselves by drawing energy via heat out of the location.

DÉJÀ VU An impression or dull familiarity of having seen or experienced something before.

DEMATERIALIZE To lose or appear to lose physical substance and to disappear from sight.

DEMON An evil spirit or being.

DOPPELGANGER An exact spirit double or mirror image of a person; usually considered to be very negative.

DREAM COMMUNICATION An experience in which a deceased individual is manifested in a dream in order to communicate with the living.

EARTHBOUND OR EARTHBOUND SPIRIT A spirit bound to Earth, unable to cross over to the other side, such as heaven, after death. This can be caused by fear, unfinished business or a lack of realization on the part of the spirit that it is dead.

ENTITY A generic term used to define a paranormal spirit, ghost or object.

GHOST The visible disembodied soul of a dead person or animal.

GHOST LIGHTS Mysterious lights that appear in the distance but have no known cause. They can be blue or yellow.

HALLUCINATION A perception of sights and sounds that are not present.

HAUNTING Any repeated appearance of paranormal activity in a location.

HOT SPOT A location where paranormal activity occurs frequently or at a higher level.

ION Electrically charged atom or molecule.

LEVITATION To lift or raise a physical object in defiance of gravity.

MANIFESTATION Tangible signs of a haunting that may be tactile, auditory or visual.

MEDIUM A person who claims to be able to communicate with or channel spirits.

MIST A photographic anomaly that appears as a "blanket of light."

ORBS Any sphere of light that appears in pictures.

OUIJA BOARD The "wee gee" is a board with pre-printed letters, numerals and words used to communicate with the dead.

PARANORMAL Events or occurrences above or outside the natural order of things that cannot be readily explained by conventional reasoning or accepted science.

POLTERGEIST A spectral phenomenon that, unlike a ghost, can move from one location to another and may be attached to a person.

PSYCHIC A person who is responsive to psychic forces and has above-average ESP abilities.

PYROKINESIS The ability to unconsciously control and, in rare cases, produce fire with the mind.

RESIDUAL HAUNTING A haunting that appears to play back a past event that occurred in that location.

SÉANCE A gathering of people in an attempt to communicate with the dead.

SHAMAN A person regarded as having access to, and influence in, the world of benevolent and malevolent spirits. The shaman practices divination and healing.

SKEPTIC A person who has an attitude of doubt toward a particular set of beliefs.

SPIRIT The energy or soul of a living or deceased person or animal.

SPIRITUALISM The belief system that the dead are able to communicate with the living, usually through a medium.

SUPERNATURAL Something that exists or occurs through some means other than any known force in nature.

WITCH A woman thought to have magic powers, especially evil ones.

ABOUT THE AUTHOR

Evie Ybarra is the mother of two, a daughter and a son, as well as a son-in-law. She considers her two children her greatest accomplishments. Her friend and confidante, Robert, is her greatest supporter. Evie now has four beautiful grandchildren, to whom she has told many stories. After having taught creative writing and history for thirty years, she now enjoys writing as a second career. Evie and her family reside in Southern California in a coastal community filled with many legends and stories.

Visit us at
www.historypress.net
...
This title is also available as an e-book